DRAWING

DRAWING CELEBRITY CARICATURES

MARTIN POPE

ARCTURUS

About the author

Martin Pope was born in Singapore in 1958 and has lived in the UK since 1966. Always artistically creative, he started drawing recognizable caricatures from the age of twelve. Now he is an established freelance illustrator, receiving regular commissions from large corporations such as JP Morgan, Sony and the Royal Bank of Scotland as well as in-house and national magazines. Caricaturing remains his main love and occupation. His first book, *Drawing Caricatures*, was published in 2008.

For more information about Martin Pope's work, visit www.martinpope.co.uk

Picture credits
Corbis: page 23 (top)

Special thanks to Claire Pope for creating the reference artworks used in this book.

This edition published in 2010 by Arcturus Publishing Limited
26/27 Bickels Yard, 151–153 Bermondsey Street,
London SE1 3HA

Project editor: Ella Fern

ISBN: 978-1-84837-479-9
AD001263EN

Printed in Singapore

Contents

Introduction

WHAT IS A CARICATURE AND CAN ANYONE DO IT?

The word 'caricature' essentially means 'loaded portrait' – in other words, it's a portrait that focuses on the subject's unique facial features and loads, or exaggerates, them. The degree of exaggeration is a matter of choice; every caricaturist has their own style, some pushing things to extremes and others being very subtle.

Can anyone learn to caricature? I believe so, but if you feel you have little drawing ability I recommend you read a good book on basic drawing skills before attempting the techniques detailed here. Drawn well, caricatures are not only entertaining to others, they are also hugely rewarding to you as their creator. They are great fun to do and are an ideal creative outlet for budding and experienced artists alike.

WHY CARICATURE CELEBRITIES?

While drawing a caricature of a close friend or relative is enjoyable and provides good practice, it won't get your artistic skill noticed on a wide scale. For this, you need to caricature someone well-known to the public. Drawing caricatures of famous people such as royalty, heads of state and government officials has been popular for centuries – indeed, there is even evidence of a politician caricatured as wall graffiti in the ancient Roman city of Pompeii, destroyed by the eruption of Vesuvius in AD79. What is new, however, is the modern cult of celebrity that feeds off the television, movies, magazines and the internet. The benefit for caricaturists is that there are now more 'celebs' in the public eye than ever before.

WHAT WILL YOU LEARN?

In this book, I want to teach you the building blocks of caricaturing, from the basic layout of features on the human head, to looking at what makes each person different and how to exaggerate to best effect. Then we'll move on to looking at full-figure caricatures, props, extreme exaggeration, and the various tools you can use to enhance your final piece. Throughout the book are examples of my own celeb caricatures for you to follow and – hopefully – be inspired by!

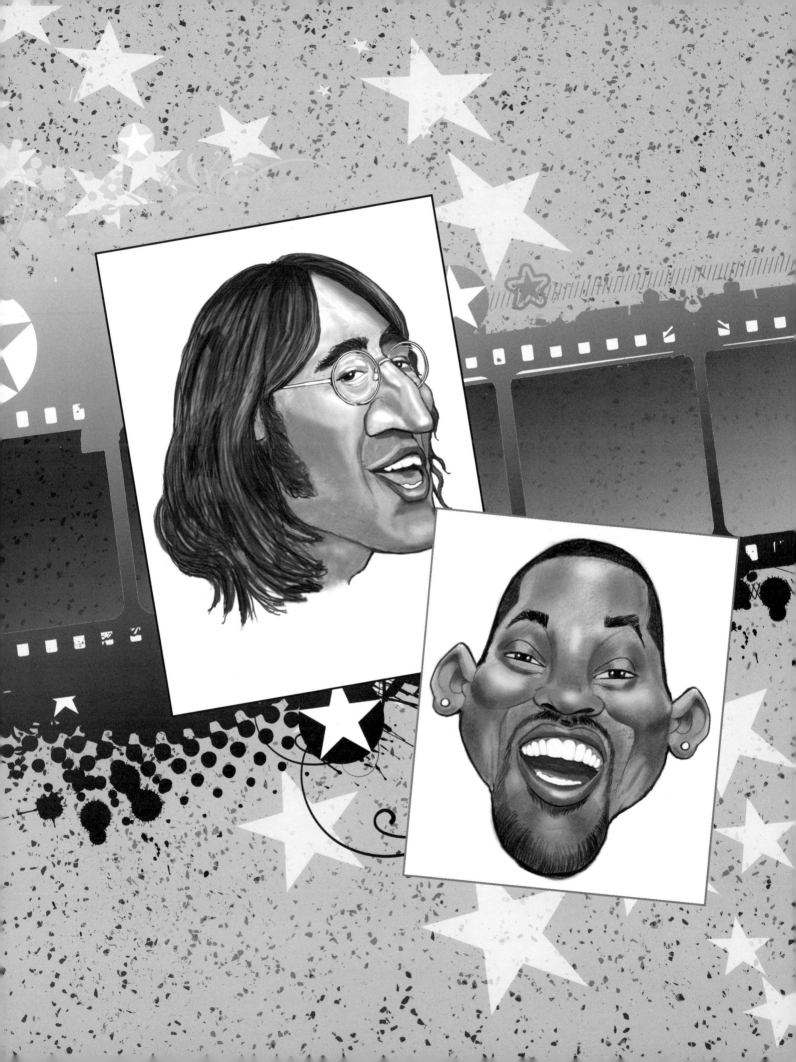

CHAPTER 1

★ First Steps

Caricaturing can seem like a daunting challenge at first, but if you start with the basics and take it step-by-step you may be surprised with the results. In this section we'll look at the materials you need to get started and the basic proportions of the human head. Then we'll learn how to study people closely in order to identify what makes them unique. Developing an eye for individual characteristics is an important part of becoming a caricaturist.

Materials and equipment

The range of materials available to artists can often be overwhelming. Here I recommend just a few that I find most useful for my work. As you get to grips with caricaturing you may discover other materials that you enjoy working with, but these will get you off to a good start.

First, you'll need something to draw with and a pencil is a good starting point. Pencils come in different lead grades from 6H (the hardest) to 6B (the softest), with HB in the middle. I use HB for all my pencil work. Another option is a propelling pencil, which never needs sharpening and takes refill leads available in various grades.

The next consideration is your drawing surface. For sketching out your initial ideas, A3 size 50gsm layout paper is ideal as its semi-transparent quality allows you to lay one sheet over another to trace anything worth keeping from your previous sketches.

For final artwork I like to use A3 size 220gsm Bristol board card. Its thickness and extra-smooth surface make it suitable for most mediums and is particularly good for ink and pencil work.

When it comes to tracing your initial drawings on to fine-quality paper or Bristol board a light box will come in handy.

Black fineliners are ideal for intricate work. You can buy these in various sizes; I use anything from 0.2mm to 0.5mm.

You will need a good-quality soft eraser to remove any unwanted pencil lines.

This pen is versatile – it has a brush tip at one end and, at the other, a tip similar to a fineliner but thicker.

Dual-tipped marker pens are very useful. One end is pointed for more intricate work while the other is flat, suitable for filling in blocks of colour or shading. Another bonus with most marker pens is that they can be refilled from ink bottles bought separately.

Water-soluble artists' painting crayons are ideal for blending together to create realistic skin tones.

Faber-Castell's Polychromos artists' pencils are great for adding intricate colour work.

Applied with a fine brush, white gouache paint is ideal for adding highlights to your finished artwork.

Sourcing reference images

Once you have chosen which celebrity you wish to caricature, spend some time sourcing photographs to use as reference. The best and usually most convenient way to find a good range of photos is to search the internet.

If you don't have access to a computer you can always do things the old-fashioned way and take a trip to your local newsagents. There is now an abundance of gossip magazines consisting of little more than photos of celebrities as well as TV magazines and newspapers with plenty of pictures.

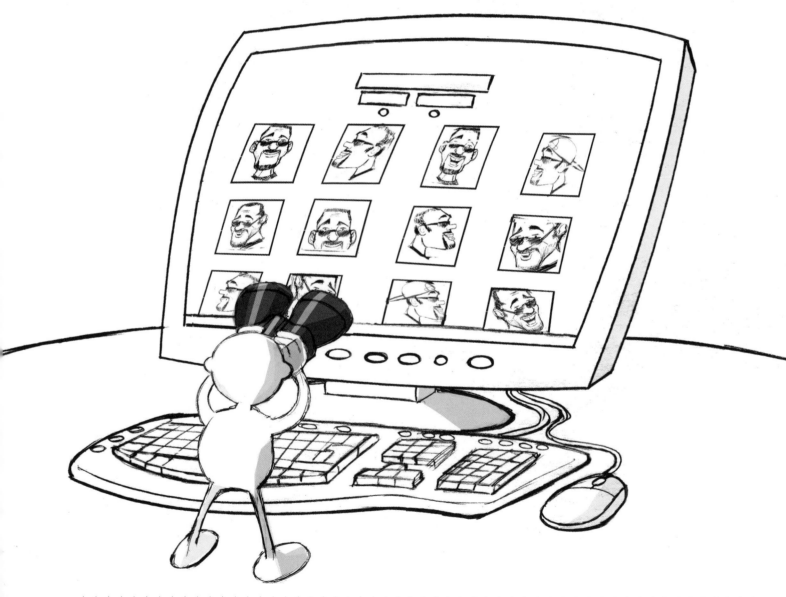

★★

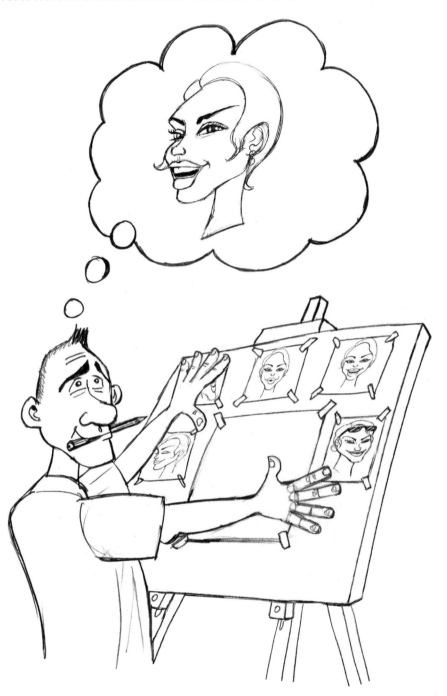

I usually collect as many photos of my subject as I can find, taken from every angle and displaying as many expressions as possible. Whatever angle you decide to draw your celebrity from, it's essential to build a mental three-dimensional image of what they look like as this will help enormously in capturing the essence of their character.

Once I have a reasonable selection of reference pictures to work from I narrow them down to about five good ones. I usually choose one that has a good representation of the angle I wish to draw my caricature from and the others act as reference to help me create the ideal expression. You may sometimes be fortunate enough to find one photo that gives you everything you need, but generally this will not be the case.

Observation and recognition

The key to good caricaturing is observation. We observe people's faces every day without giving it a second thought, and the more often we see a particular face, the stronger our recollection of it becomes. In the case of celebrities, we may encounter their image several times a day in print and on a television or computer screen.

Fortunately for us, human beings have facial layouts and characteristics quite distinct from one another. What you as a caricaturist must do is be aware of the information your brain is receiving and keep it in your conscious mind, rather than letting it take the normal route to your subconscious to be stored in your long-term memory bank.

Take a look at the selection of celebrity caricatures on these pages. The reason you can recognize who they are is that not only are they different from each other in age, gender and skin colour, each face is unique. Therefore, out of all the hundreds or maybe thousands of other faces you have stored in your memory you are able to identify these few. Observation and face recognition are really part of the same process; we observe what is unique and different about a face, which then enables us to recognize it.

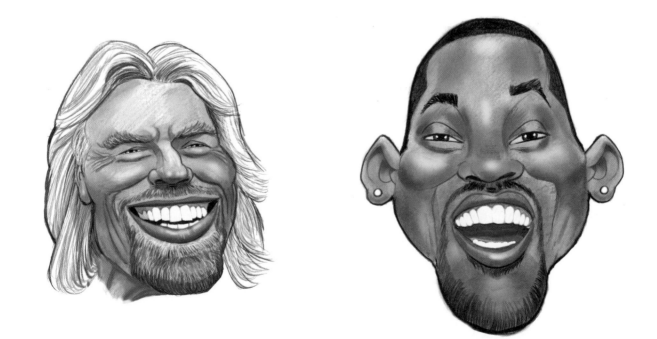

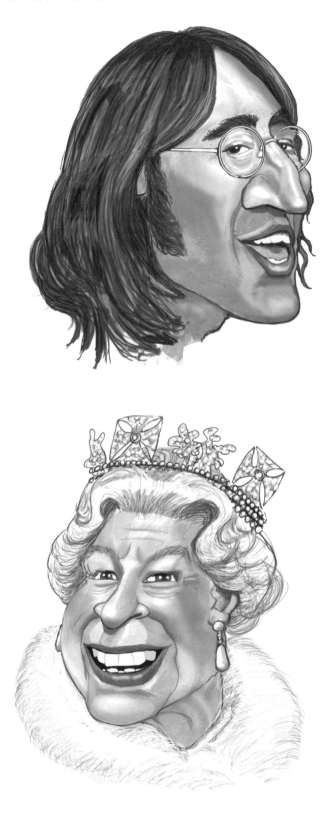

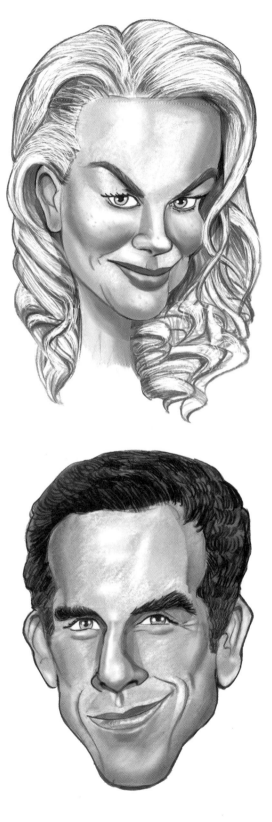

Proportions of the head

To be able to define what is unique about the celebrity you choose to caricature, it helps to have an idea of the basic shape, layout and measurements of an average human head so that you have something to use as a comparison.

A This line divides the head in half horizontally. When placing the eyes along this line, imagine that the head is divided into five sections, each the width of an eye.

B The tops of the nose, eyes and ears are in line with each other.

C The bases of the nose and ears are in line with each other.

D The distance from the bottom of the chin to the base of the nose measures about 30 per cent of the total length of the head.

E The corners of the mouth are often in line with the centre of the pupils.

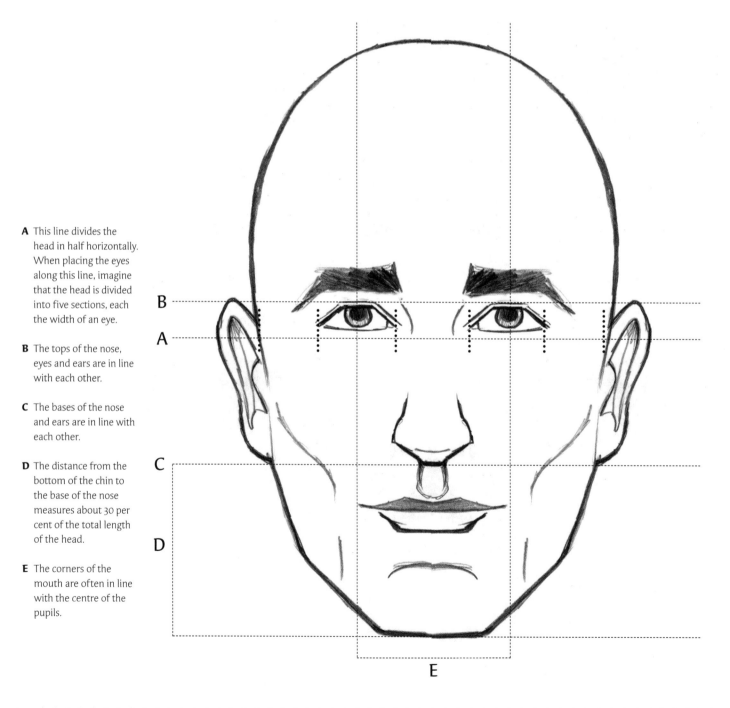

★★

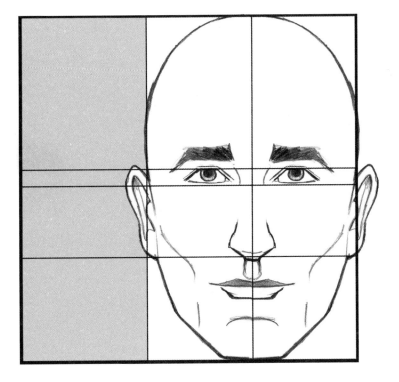

Here I have placed the same head in a square grid. When viewed face on, the head fills approximately 70 per cent of the square.

With another head in the same square you can immediately see the differences in proportion. This head is wider, taking up a larger percentage of the square. The horizontal guidelines show that the eyes are set slightly higher and the nose is considerably shorter, increasing the gap between the nose and mouth.

I am not suggesting you lay this grid over every caricature you attempt to draw. The idea of this exercise is merely to focus your attention on identifying the differences between one face and another by using the average face as a guideline.

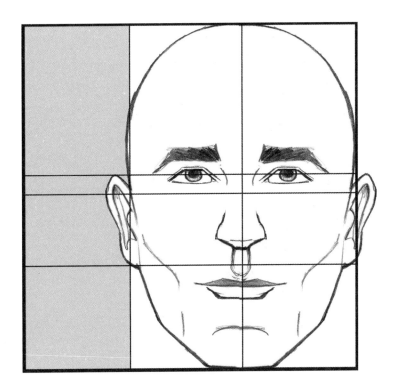

PROPORTIONS OF THE HEAD IN PROFILE

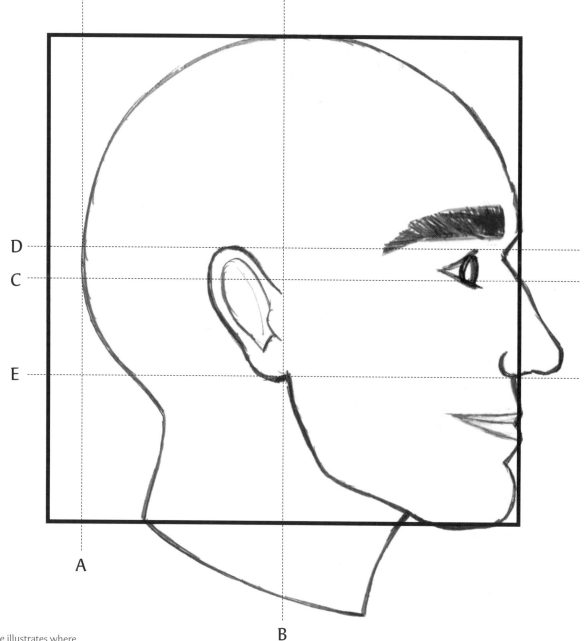

A This line illustrates where the back of the head finishes in relationship to the square. As you can see, it falls just short of filling 95 per cent of the square. However, because the difference is so small, it is still worth using a square as a guideline for the depth of the head in profile – just remember to draw slightly within it.

B This line divides the square in half vertically. The front part of the head to the right of the ear lobe comfortably fills 50 per cent of the square. The ear is set behind the centre line, on the left side of the square.

C This line divides the head in half horizontally and, as with the full-face illustration, runs just below the eye.

D The tops of the eyes, nose and ears are in line with each other.

E The bases of the nose and ears are in line with each other.

Whichever angle you decide to caricature your celebrity from, it always pays to view them in profile as you will gain valuable information about the size and layout of their features that will not be so apparent from other angles. Seen face-on, the character below would no doubt look a little different from the one on the opposite page, but from this angle the variation in features jumps off the page.

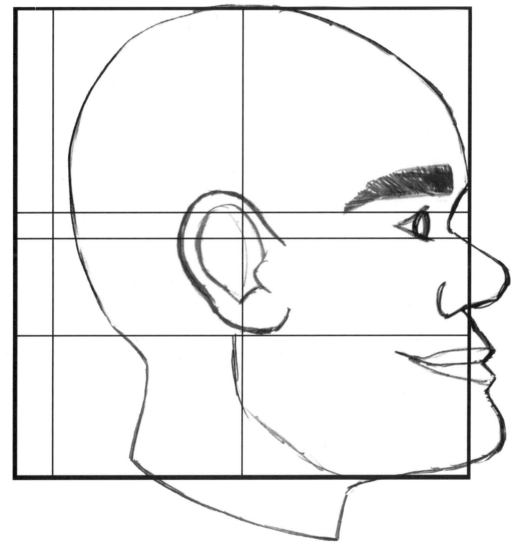

The forehead slopes back steeply and the overall head shape takes up less of the square than the average head opposite.

The ear is larger, taking up space to the right of the vertical centre line and also rising way above the average guideline for the top of the ears.

The nose is upturned and short. It is positioned a fair way above the guideline for the base of the nose.

The mouth and chin protrude right outside the square.

Layout of facial features

Identifying the layout of facial features as a group is just as important as observing their individual shape and size. As a unit, the features form characteristic patterns which help us to distinguish between one face and another.

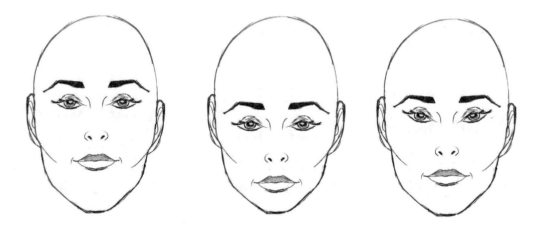

Note how the three faces above seem to have different expressions: the one on the left looks confident and haughty, the middle one looks a little sad and that on the right appears more impassive. In reality, they have the same expression and their features are identical in size and shape. It is the fact that their features are laid out on different areas on the head which makes them appear quite dissimilar.

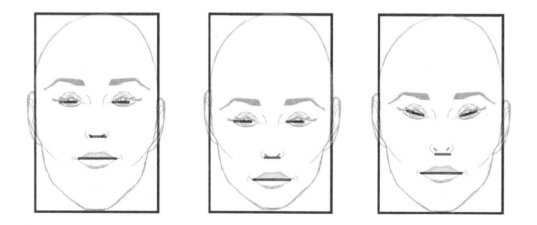

To simplify what we are looking at, it is possible to determine the differences between these faces by drawing just four small lines within a rectangle.

★★★

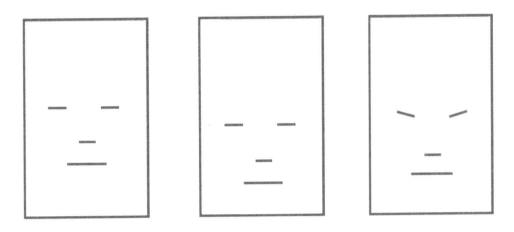

As you can see from the patterns above, the lines on the left are positioned relatively high up in their rectangle, while those in the middle are much lower. Those on the right are also positioned fairly low and the two lines that represent the eyes slant down toward the centre. Try to train your eye to see differences like these. The face layout is important – if you get it right the rest will follow.

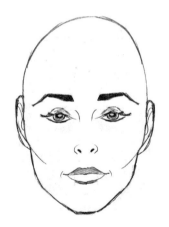

The three face patterns below differ from my original to the left. See if you can identify what the differences are. *(See below for answers.)*

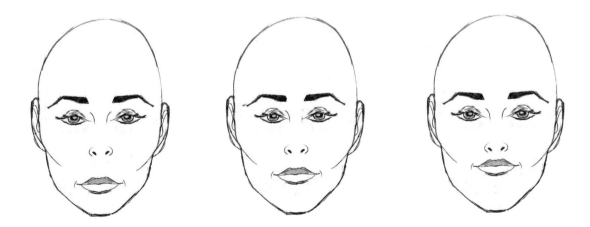

Left: Mouth is lower down. Centre: Eyes are closer together. Right: Mouth is positioned higher up.

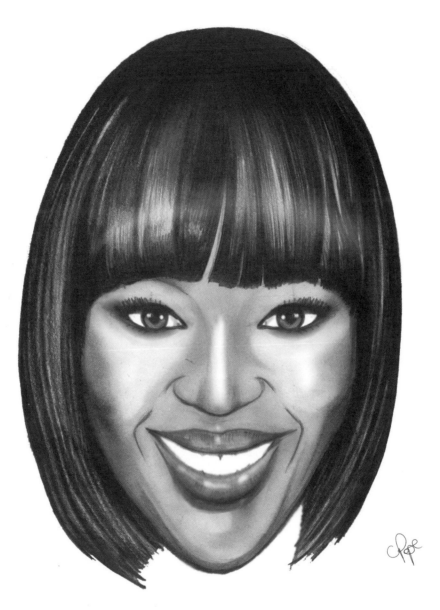

SYMMETRICAL & ASYMMETRICAL FACES

This portrait, drawn by artist Claire Pope, is of the supermodel Naomi Campbell. With features perfectly aligned with one another, hers is a good example of a symmetrical face.

It is quite rare to have a symmetrical face. Combined with regular features, the effect is of someone usually regarded as very attractive. Individuals who make their living in front of a camera, such as supermodels and film stars, may fall into this category, but a large percentage of us do not. Fortunately for us caricaturists, most people have asymmetrical faces to some degree, giving them extra individuality and us more to work with.

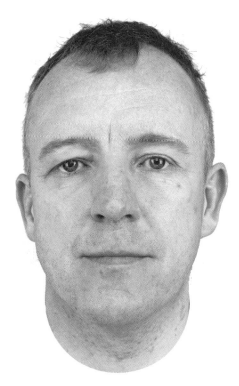

To illustrate this further I have taken a photograph of a fairly average-looking man. If you look closely you will see that the eye on the left-hand side looks quite different from that on the right. The ears also do not match.

The two photographs below are mirror images of both the left- and right-hand side of his face, illustrating how he would look if he did have a symmetrical face. The images could be of two completely different people.

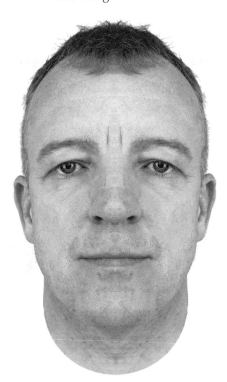

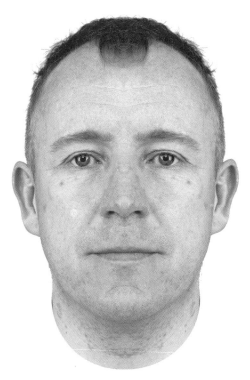

Facial expressions

Our faces are incredibly flexible and are capable of displaying many variations of expression, each one providing a fairly accurate insight into our emotional state. As there are so many different facial expressions we will only be scraping the surface of this fascinating subject – to cover it fully we would probably need another book on that subject alone.

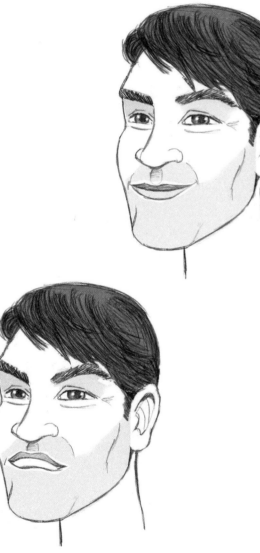

This is a character I have created to help illustrate various facial expressions. He may not be a celebrity but he looks pretty content here, with a smiling mouth and slightly narrowed eyes.

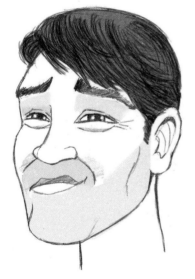

Now he is not so happy, though. With eyebrows slanting down toward the centre of his face and a downturned mouth, he is indicating distaste.

This expression shows uncertainty. The eyebrows are raised, the eyes are partly closed, and the mouth is pulled upwards at one side.

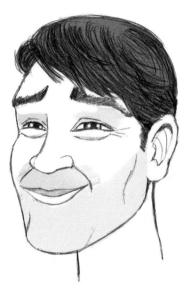

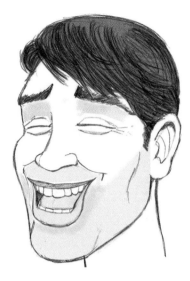

When someone smiles their cheek muscles rise, pushing up the flesh beneath the eyes and forming wrinkles around them.

When someone laughs, the eyelids will sometimes close shut. If the mouth opens wide the jaw will fall, so the face becomes longer.

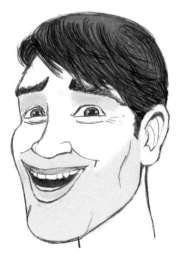

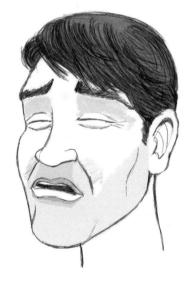

This is an expression of pleasant surprise. As with smiling and laughter, the cheekbones look more pronounced as the muscles rise, forcing the flesh to partially cover the base of the eyes. However, the upper eyelids remain wide open.

In this distraught expression the face appears to sag, losing a lot of its form. The cheek muscles drop and the mouth becomes limp.

CHOOSING THE RIGHT EXPRESSION

When it comes to capturing an accurate likeness of your subject, their expression is almost as important as their features. We all display a range of facial expressions, but there will be some we use more than others and some that are unique to each individual. When I decided to caricature the US movie star Will Smith there was no shortage of reference photos available, but I couldn't find a single one that showed the expression I wanted to use.

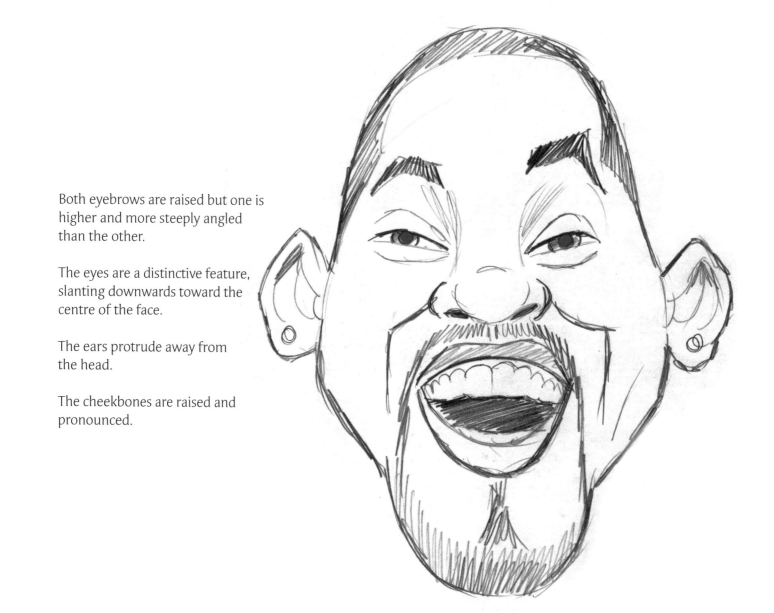

Both eyebrows are raised but one is higher and more steeply angled than the other.

The eyes are a distinctive feature, slanting downwards toward the centre of the face.

The ears protrude away from the head.

The cheekbones are raised and pronounced.

Will Smith has a very animated face, often displaying an abundance of energy and humour, and this is what I wanted to capture in my caricature. My reference for this came not only from an amalgamation of photos but also from my own memories of Will's numerous film and television appearances.

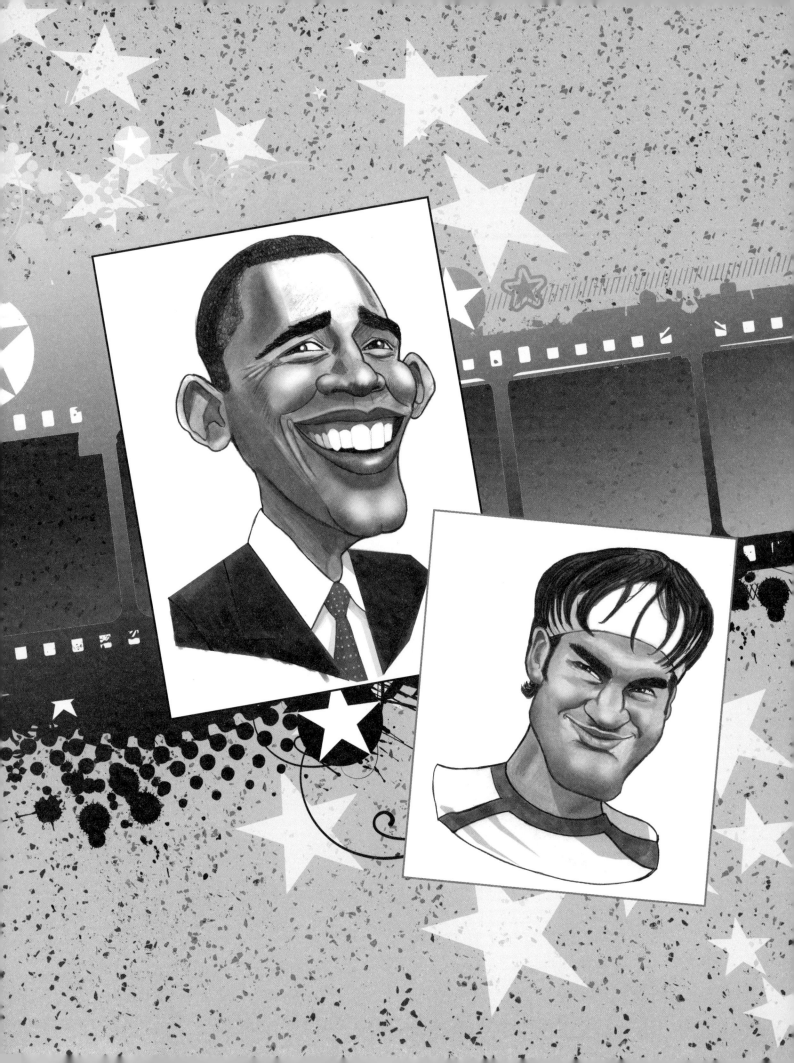

CHAPTER 2

★ Starting to Caricature

Now you have some idea of the approach behind caricaturing and the importance of observation, you are well set to make a start. In this chapter we'll look at facial features and hairstyles in detail and learn how to make the most of them in your caricature. Then we'll build up caricatures from different angles – face-on, profile and three-quarter view – as well as learning how to draw a caricature by head shape.

The features in detail

EYES

Capturing your celebrity's eyes will make all the difference in creating a good caricature. Apart from colour, eyeballs are quite similar – what makes one pair of eyes different from another is what goes on around them. The eyebrows, lashes, lids and folds of skin around the eyes all play their part in creating individual character.

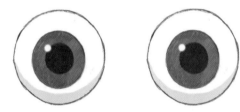

Let's take a look at the eyeballs on their own. Usually they move in sync with one another. In young people the edge of the iris is generally in sharp contrast to the white of the eye, but with age this tends to blend and become less defined.

Notice how the pair of eyes to the right look rather comical. That's because they are out of sync, looking in opposite directions. Although it doesn't happen to this extreme, sometimes the left and right eye are not exactly in line with one another. Also note that because eyeballs are spherical, when they are viewed from the side the iris and pupil appear oval rather than circular.

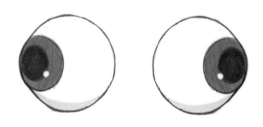

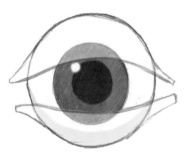

This image illustrates how the skin folds over the eye, covering up a large percentage of the eyeball.

It's fair to assume these eyes belong to an elderly man. With age, more wrinkles appear around the eyes and bags form beneath them. The eyebrows often become more bushy, though in the case of women they may become sparse.

Note that the left eye drops slightly lower than the right and the left eyelid covers more of the iris and pupil than the right. If there is a difference between the eyes it's worth exaggerating.

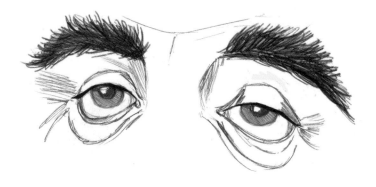

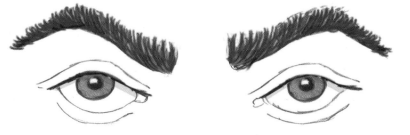

This illustration shows a younger man, so there are no bags beneath the eyes, less bushy eyebrows and fewer wrinkles.

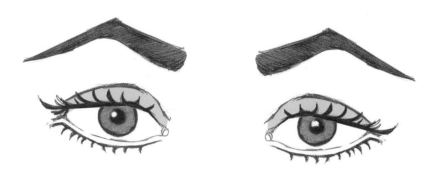

There is no mistaking that these eyes belong to a woman, with neatly plucked eyebrows, eyeshadow on the eyelids and mascara on the eyelashes. Not every woman would go to this trouble, but there are few celebrities who wouldn't.

EXPRESSIVE EYEBROWS AND EYES

We've looked at facial expressions on pages 24–7, but because the eyes are so expressive they warrant their own section. You can tell from someone's eyes whether they are sad, happy, excited, angry – in fact you can read more or less any emotion. The angle of the eyebrows, the direction of the eyes and the amount of coverage the lids provide all play their part in displaying an emotion.

Eyebrows raised and eyes rolled upwards could indicate daydreaming.

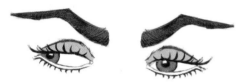

Eyebrows angled downwards toward the centre and eyes to the side with the lids partly closed suggests a devious expression.

One eyebrow cocked higher than the other and eyes to the side may display excitement and interest, or perhaps anxiety.

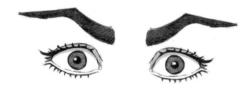

Anger or determination are displayed when the eyebrows are angled downwards toward the centre and the eyes are wide open.

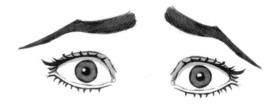

Both eyebrows raised and eyes wide open usually indicates fear or surprise.

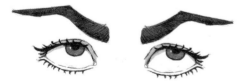

In boredom or annoyance, the eyebrows are angled downwards toward the centre, the eyes are rolled up and the lids partly cover the eyes.

Here are the eyes and eyebrows of some of the celebrity caricatures featured throughout this book. As you can see, they are all very different, but can you identify who they are?

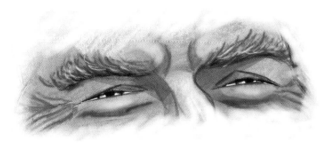

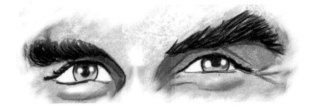

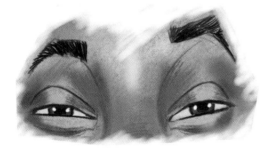

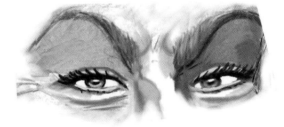

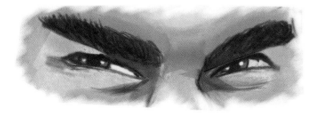

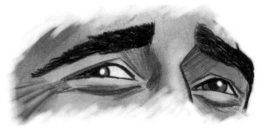

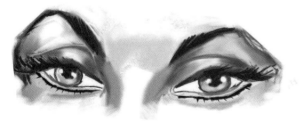

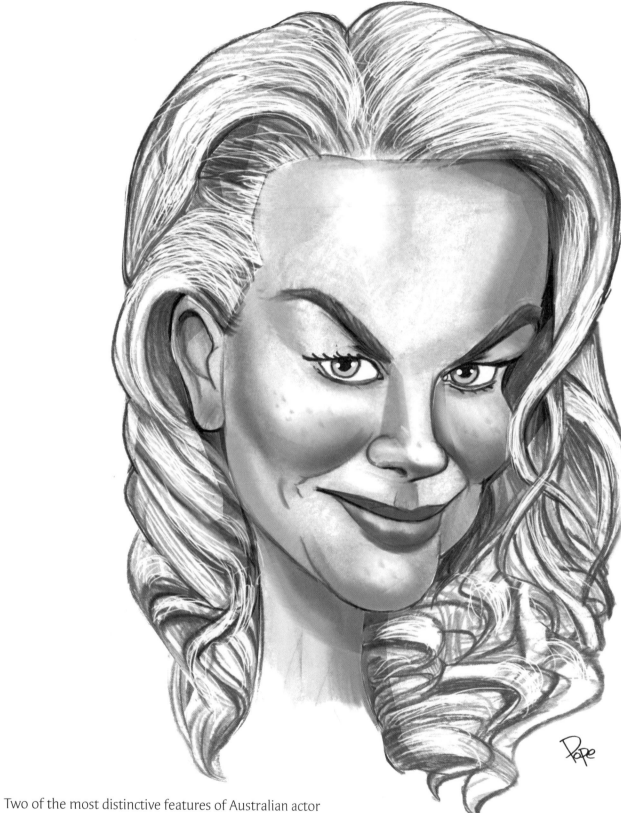

Two of the most distinctive features of Australian actor
Nicole Kidman are her arched eyebrows and deep-set eyes.

MOUTHS

Of all the facial features the mouth is the most flexible, taking on many different forms as people smile, laugh, purse their lips in disapproval and so on. Its appearance in both size and shape can change significantly, so it can be quite complex to draw.

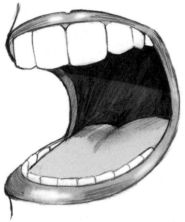

When someone is yawning or yelling the lips stretch and appear thinner as the mouth opens wide, exposing the teeth and the tongue. This is when the mouth looks at its largest.

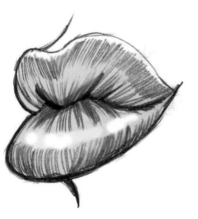

In contrast, this illustration shows the mouth puckered up for a kiss. The lips are drawn in tightly and appear fuller. In this form the mouth looks considerably smaller than in the illustration above. As the teeth and tongue are not on display it was less complex to draw.

The shape and fullness of the lips can vary a lot from one individual to another. Generally speaking the bottom lip is thicker than the top one and has a curved shape, while the top lip is usually flatter and bowed to a varying degree in the centre.

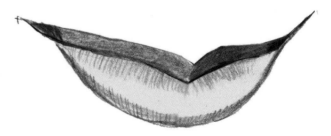

★★★★ **STAR TIP** ★★★★

Full lips are often seen as being attractive, especially in women, and many celebrities have perfected a pout that makes the most of this feature.

SHOWING TEETH

Our mouths contain teeth of different shapes and sizes. The ones worth paying special attention to are the canine teeth, which have a particular pointed shape, and the top central incisors because they are usually the longest. Any difference from the norm is worth exaggerating as this would be a characteristic feature of your subject.

If the canine teeth are noticeably more pointed than the average, then exaggerate the point a little more.

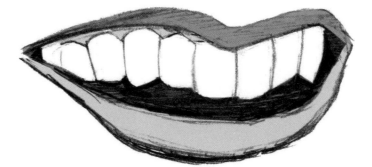

The top central incisors on this set of teeth are shorter than the norm, so it's worth emphasizing that by making them smaller still.

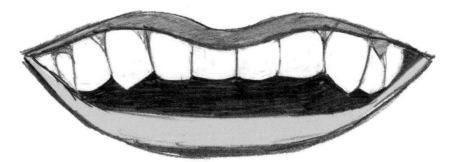

It's worth paying special attention to your subject's teeth as they may well turn out to be one of their most noticeable individual features for you to work with. A set of teeth can be very distinctive, not only by virtue of their size and shape but also by their angle.

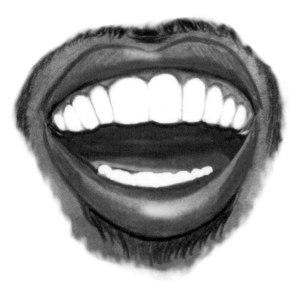

Most celebrities make our job more difficult by having great teeth. Even if they don't possess them initially, they usually acquire them through cosmetic dentistry. This perfect set is from my Will Smith caricature (see page 27).

Occasionally we strike lucky with a celebrity who is happy to keep their teeth the way they are, like this great set from my Freddie Mercury caricature (see page 81). Not only are they large, they also jut outwards and have a nice gap on the side.

This set of teeth is from my Madonna caricature (see page 113). She also has a gap, but hers is in the centre.

GUM DISPLAY

How much we see of the gums when people smile and talk varies from one individual to another. Together with the teeth, they form a characteristic part of a person's appearance.

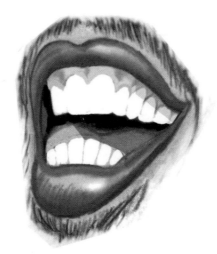

This mouth is from my Russell Brand caricature (see page 53). Not only are all of his upper teeth on display but also a large percentage of the gum above them.

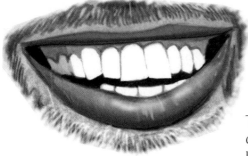

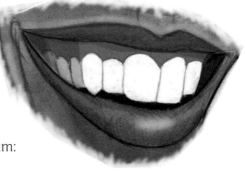

These two mouths also display a fair amount of gum: left, Richard Branson (see page 127), and right, Barack Obama (see page 65).

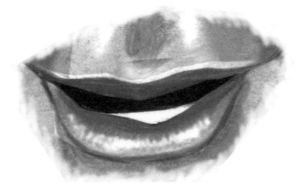

Ozzy Osbourne's mouth is in complete contrast to all the above (see page 95 for the whole caricature). As you can see, the top lip not only covers the gums, it also hides the top teeth entirely.

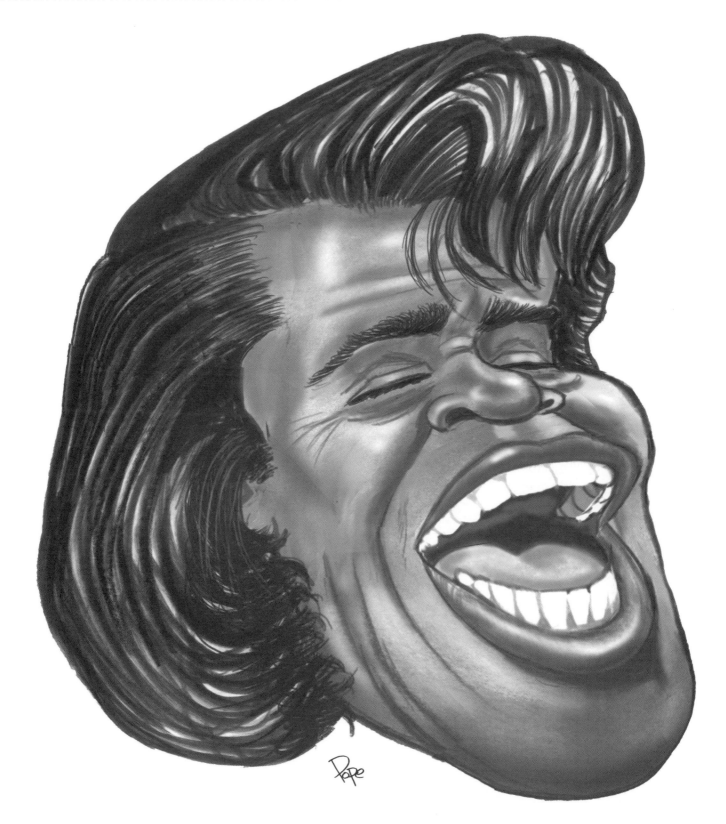

What a mouth! The late great James Brown. Notice how
the gums beneath his bottom teeth are visible.

NOSES

The shape and size of the nose can be quite diverse, from small to large, upturned to hooked and thin to broad. Like the teeth, it may be one of the most characteristic features of the celebrity you decide to draw so it is worth studying in detail. Get the nose right and your caricature will be well on the way – get it wrong and you will struggle to achieve a good likeness no matter how accurate the rest of your drawing is.

Don't fall into the trap that ensnares a lot of caricaturists by exaggerating the size of every nose you draw. If it's small, leave it be and exaggerate the size of other features that warrant that treatment. If it really is big, then by all means make it huge.

The nose can look very different depending on the angle it is seen from. When you view it from slightly below the nostrils are more exposed, so if your celebrity has large nostrils it may be beneficial to draw your caricature from this angle to give them more emphasis.

As you can see from the selection displayed on these two pages, each nose is unique, offering you as the caricaturist a great facial feature to work with.

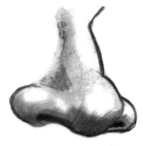

If the nose is short and flat, long and thin, round and bulbous, or has flared nostrils, then exaggerate those details.

The late John Lennon had an interesting nose. It was not particularly big but it was unusual and proved a lot more difficult to caricature than I believed it would.

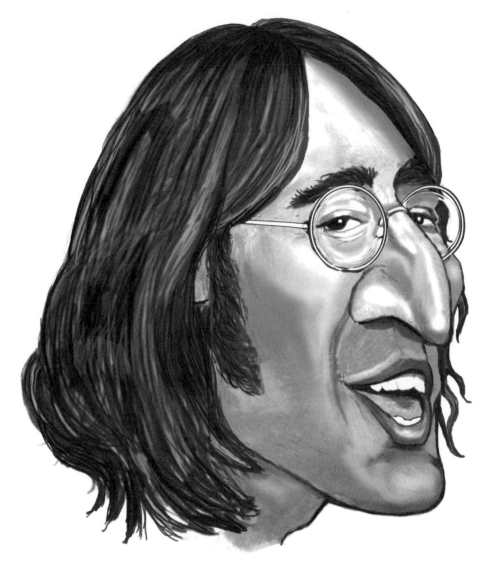

I noticed that most other caricaturists' attempts at Lennon were drawn full-face and the nose certainly seemed a lot easier to capture from that angle. Taking the easy option is always tempting, but I wanted to draw my caricature of Lennon from a three-quarter angle and to make a feature of his nose. As you can see, it was not until I finished the caricature that I had to accept I had got the nose wrong – it's too long and too hooked.

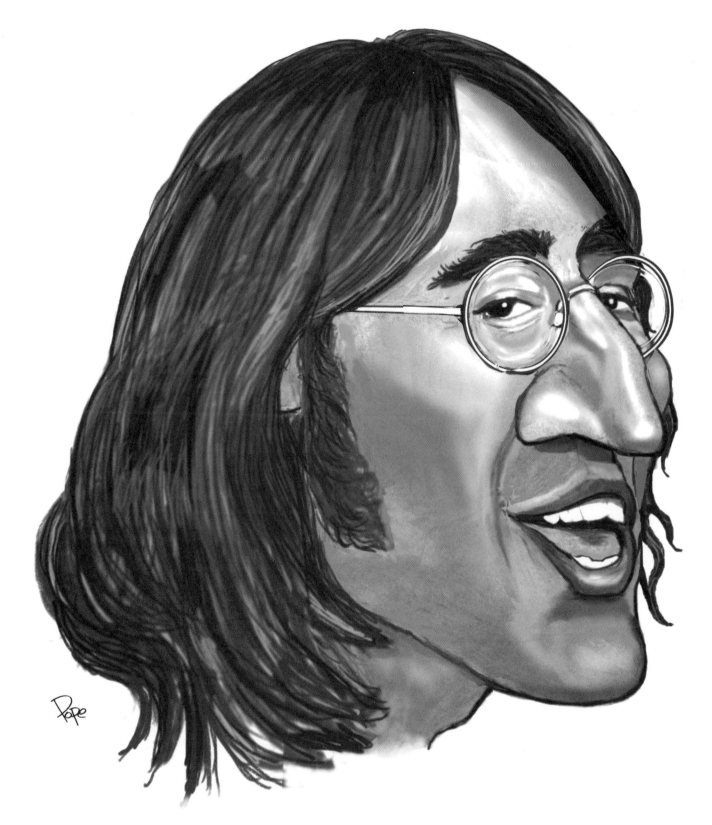

If you have been struggling to get a facial feature right, my tip is to give yourself a break. Upon your return, looking at your drawing with fresh eyes, you will often spot immediately what you could not previously see. Above is my final caricature of John Lennon – one that I am pretty satisfied with, particularly the nose!

EARS

The ears can have quite an impact on an individual's appearance. It's not only their shape and size that make them look different but also the angle at which they protrude from the head.

These sketches illustrate just how different one set of ears can look from another. Their structure is composed of a combination of hard and soft tissue, which helps to create an unusually wide range of shapes and angles.

When drawing in profile, ears don't have such an impact on the overall look of your subject as they do in a full-face or three-quarter view. This is because the ear is seen flat on the page, so the angle of protrusion isn't visible.

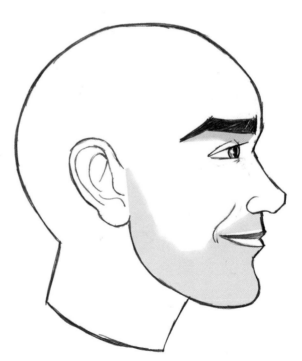

If the celebrity you are drawing has a pair of ears that stick out more than average, choose a full-face or three-quarter angle so that you will be able to make the most of them as a distinguishing feature, exaggerating them to achieve the best result.

From this face-on sketch we can see the character has normal-sized ears that are flush to the head, sloping backward rather than protruding.

This is the same character, only this time he has rather large, protruding ears. As you can see, he looks very different from the sketch on the left – his head now appears much wider and shorter. In fact, it's just the ears that have changed.

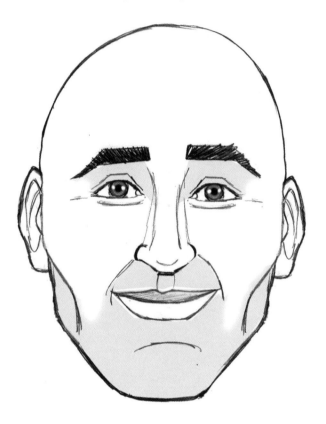

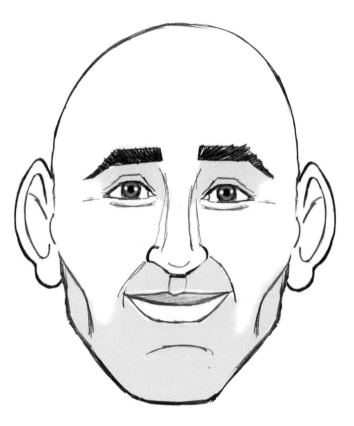

★ ★ ★ ★ ★ **STAR TIP** ★ ★ ★ ★ ★

Female stars with large or protruding ears are likely to choose a hairstyle that keeps them covered. You can always show a tip of ear protruding from the hair for a comic touch, but beware of exaggerating ears if they are not an obvious feature of your chosen celeb.

Jawlines and chins

The basic appearance of the jaw is mainly determined by the shape and size of the jawbone. Just the shape of the jawbone alone can make a man appear more masculine or a woman more feminine. The two sketches below show the bottom half of the face from both sexes, based on our stereotypical good-looking celebrity.

The man has a strong, powerful neck, a square chin and a wide jawline.

The woman appears to have a longer neck than the man, but that's only because it's thinner and more elegant. The chin and jaw are more curved and pointed.

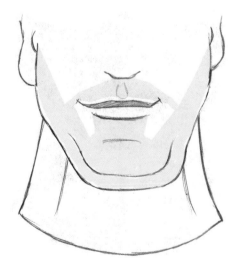

This sketch has drastically changed in appearance from the one above by virtue of our subject now sporting a double chin. Unfortunately, with age that extra layer of fat and skin tissue often appears – but thanks to cosmetic surgery a celebrity with a double chin is becoming quite a rare species nowadays.

★★★

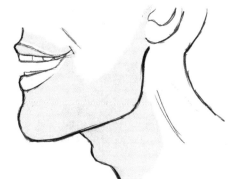

When you are drawing a chin and neck in profile, note that the Adam's apple will be visible on a man's neck.

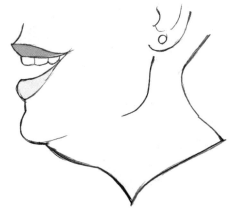

Here are the same jawlines as above, but with extra weight around the neck area.

To the left, a rather large chin and angular jawline.

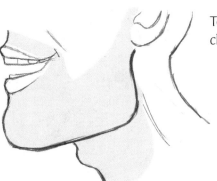

To the right, an average jawline with a small chin that slopes backwards.

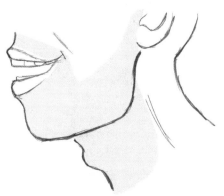

To the left, a long, pointed, protruding chin.

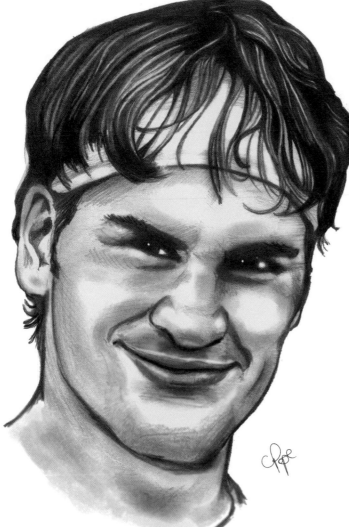

This is a portrait drawing of Roger Federer, probably the greatest tennis player of all time. It's a good likeness, but from this angle it's not apparent just how much Roger's chin protrudes. This is a good example of why it's essential to gather reference photos from all angles to identify the unique features of each celebrity you decide to caricature.

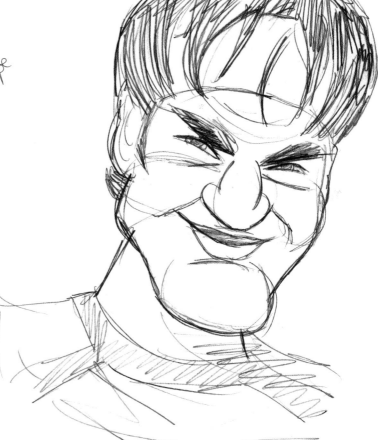

I drew this caricature pencil sketch from the same angle as the portrait above. As you can see, I have accentuated a number of Roger's features but his chin has been my main focus.

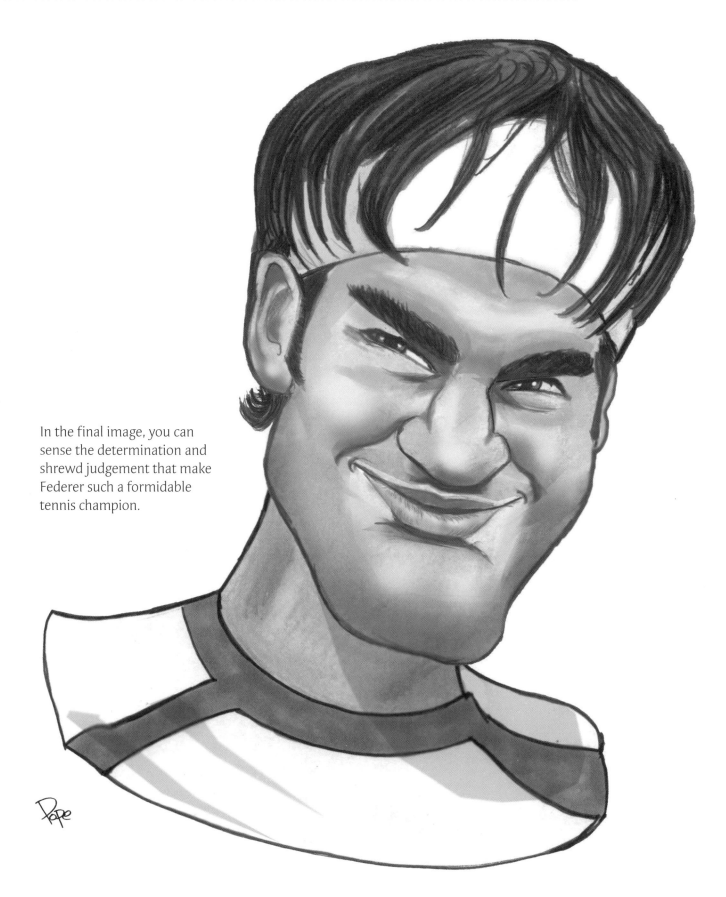

In the final image, you can sense the determination and shrewd judgement that make Federer such a formidable tennis champion.

Hairstyles

The hairstyle your subject chooses to wear can have a huge impact on their appearance and, rightly or wrongly, the way they are perceived. Take a look at the characters below – they all have the same face but different hairstyles.

If your subject has an unusual hairstyle it is worth making a feature of it. Identify what makes it unique and exaggerate it.

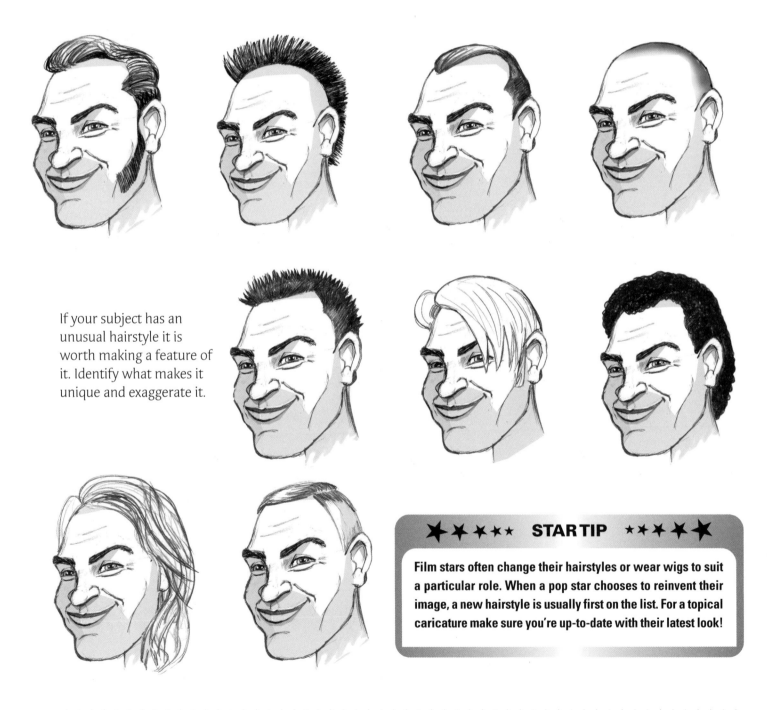

★★★★ **STAR TIP** ★★★★★

Film stars often change their hairstyles or wear wigs to suit a particular role. When a pop star chooses to reinvent their image, a new hairstyle is usually first on the list. For a topical caricature make sure you're up-to-date with their latest look!

The three illustrations on the right are all of the same woman, drawn face-on. From this angle it is more apparent how much a change in hairstyle can influence the shape we see. On the far right are silhouettes of the same drawings. Looking at these purely as shapes, the difference between them becomes even more obvious.

A beard and moustache can be such a defining feature of an individual's appearance that you might not even recognize him clean-shaven.

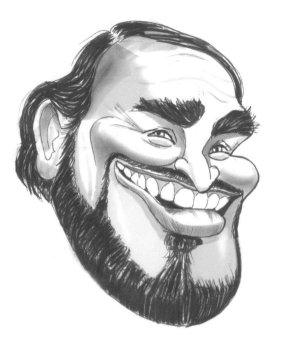
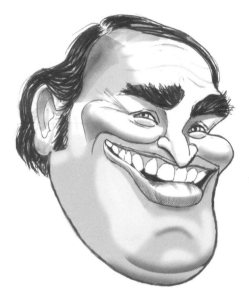

Opera singer Luciano Pavarotti (above) was immediately recognizable with his beard and moustache, but without them (above right) you would probably not recognize who the subject was. The same goes for the former US president Abraham Lincoln (below). A beard with no moustache is quite an unusual look which makes him easily distinguishable from other American political figures. Without the beard his main identifying feature is lost.

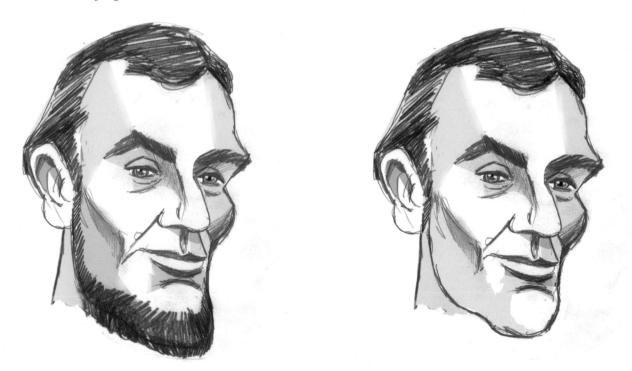

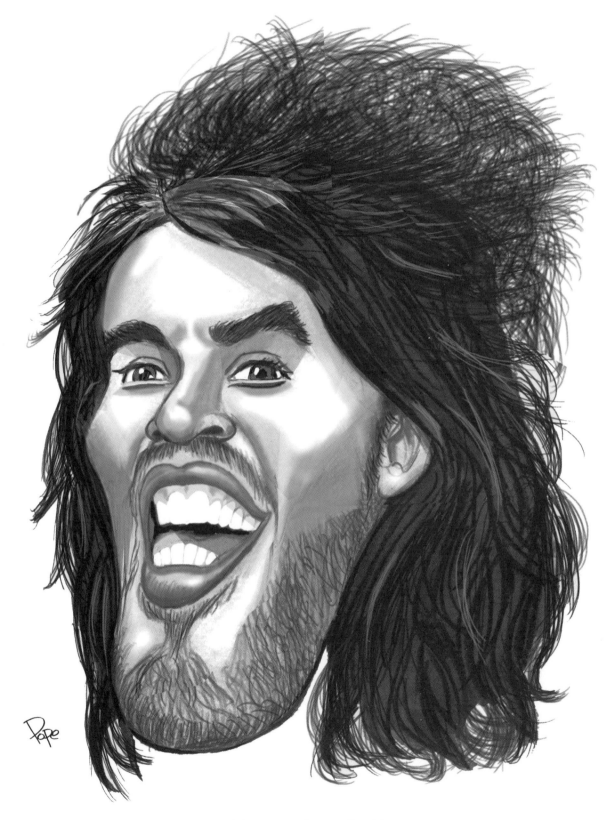

British comedian and actor Russell Brand was an ideal celebrity to caricature for this section. His wild, stylized hair, together with close-cropped beard and moustache, are all part of his extrovert image.

Drawing a caricature face-on

Most caricaturists tend to draw their subjects either face-on or from a three-quarter view. While the latter has its advantages, the former is easier for a beginner as there are fewer angles and no perspective to worry about. If your subject's features look very asymmetrical or their ears stick out more than usual, drawing them face-on allows you to illustrate these characteristics to the full.

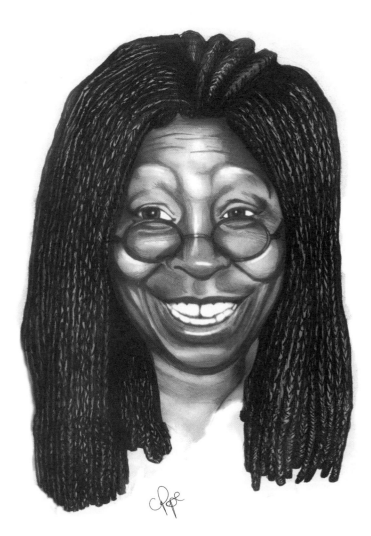

Whoopi Goldberg has a fairly symmetrical face and in this portrait her ears are covered by her hair. However, because she has such distinctive features she still makes a good subject to caricature face-on.

As usual, I used a number of reference photos, including the one that acted as reference for this portrait. Looking at photos taken from various angles gave me a clearer idea of the position and angle of her teeth.

Whoopi has quite dramatic features, so it's fairly easy to see how they differ from the average. To help illustrate this further I have placed the portrait within the grid used on page 17, alongside our average head.

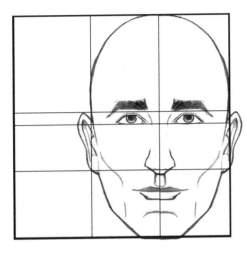

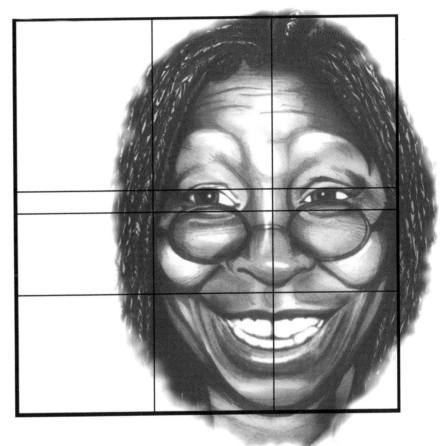

There isn't a huge difference in the alignment of the features, though the nose is quite a bit shorter and, considering the mouth is raised in a smile, there's a fairly large space between the base of the nose and the top of the mouth. What makes this face dramatically different is the size of the mouth, the width of the nose, the pronounced cheekbones and the tapered jawline.

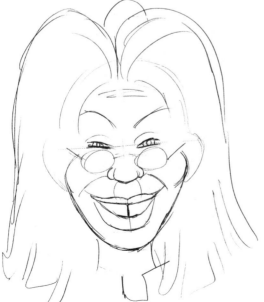

This was my first draft sketch. After consulting other reference photos I decided I wanted to make the hair more of a feature, rising to a greater height and looking less uniform than in the portrait opposite.

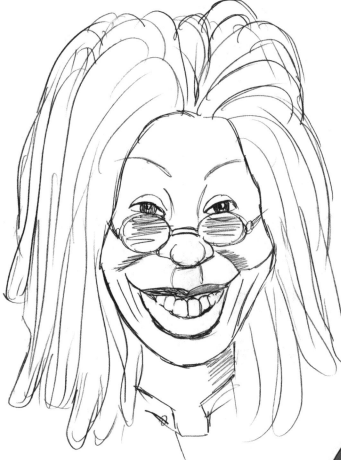

With more detail applied around the mouth area and to the dreadlocks, this caricature sketch started to show some resemblance to my subject.

When tone is added to a sketch, errors in the proportions are often revealed. As soon as I blocked in the hair I realized that the face needed to be much wider.

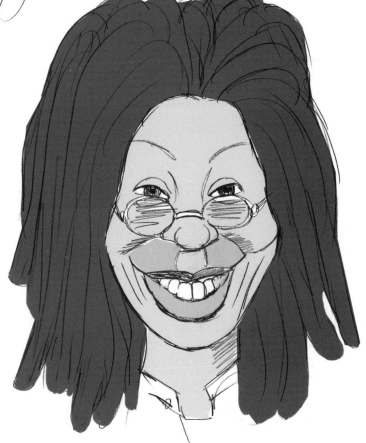

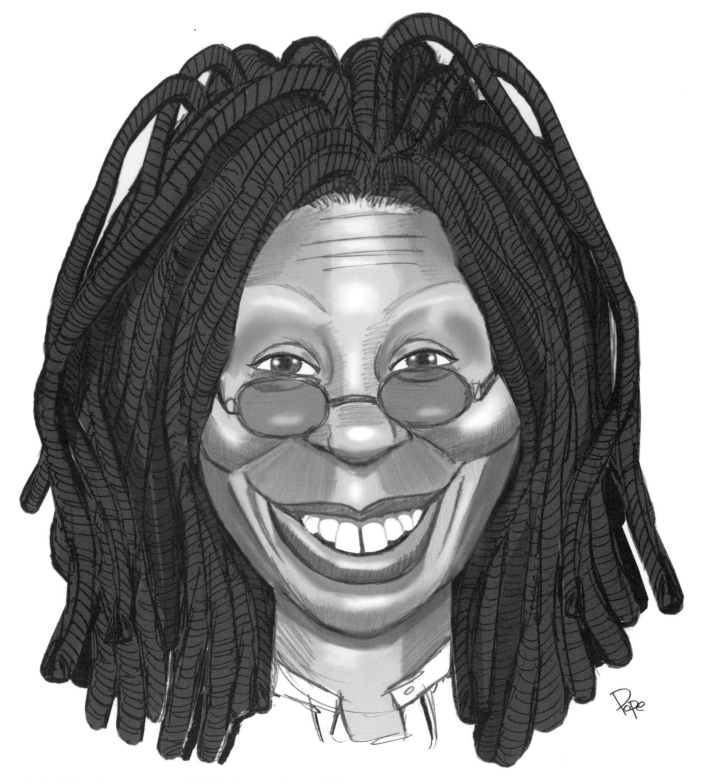

Here is the finished caricature, which I believe works well. The characteristic features that I chose to exaggerate are the large mouth, the gap between the front teeth, the large space between the top lip and base of the nose, the pronounced cheekbones, the almost non-existent eyebrows and, of course, the dreadlocks.

Drawing a caricature in profile

If you try to look at yourself in profile using a mirror, you'll realize that it's nearly impossible. This explains why we're not very familiar with our own profile view – we only see it in photographs. However, we see the faces of celebrities so often we can recognize them just as well in profile as we can full-face. Caricaturing from the side view can be fun, especially if your subject has a large nose or an otherwise unusual profile.

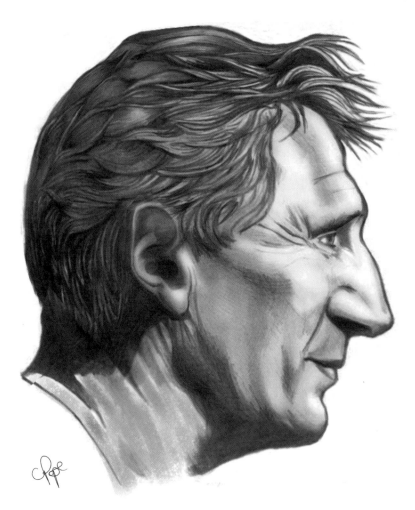

This is a pencil portrait of the film star Liam Neeson. As you can see, he has a very unusual profile and this makes him a perfect celebrity to caricature from a side-on view.

I wanted to have my subject smiling in my caricature, so I needed more reference material for the mouth and cheekbones. As usual I turned to a range of reference photos, including the one used for this portrait.

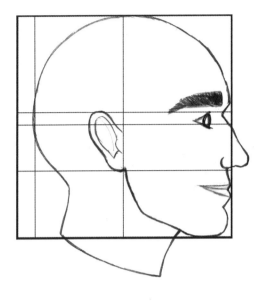

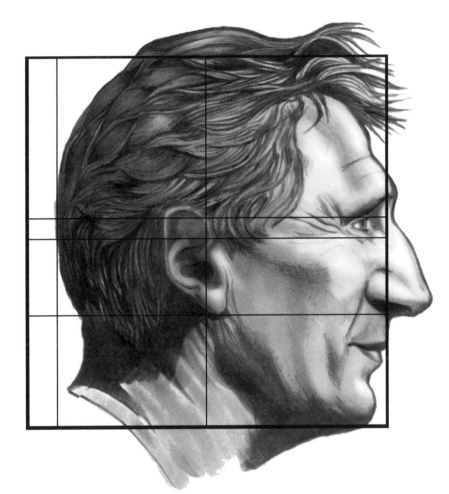

As with the face-on portrait of Whoopi on page 54, the unique characteristics of Neeson's face seen in profile are obvious. Comparing it in a grid with our average head, we can see that a section of the forehead juts forward, protruding outside the square, as does the bridge of the nose. The ear sits a fair bit higher than the guideline and the eye is very small. The chin is also quite small and sits back further inside the square than normal.

This was my first rough pencil draft. As you can see, I emphasized the information gained from the grid and a resemblance is forming.

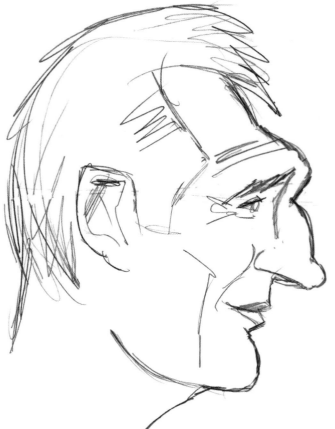

Using semi-transparent layout paper, I traced over my first sketch, making slight adjustments such as exaggerating the brow still further. Sometimes the adjustments you make in your early sketches are mistaken; in this case I made the jawline too strong.

My third attempt was a combination of both sketches with a few more adjustments on the way and some pencil shading. This time I made the jawline a little too small, but the sketch was good enough to use as the base for my final artwork.

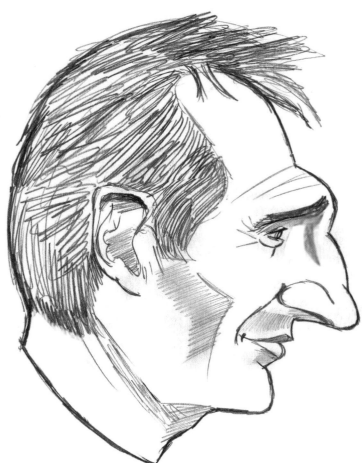

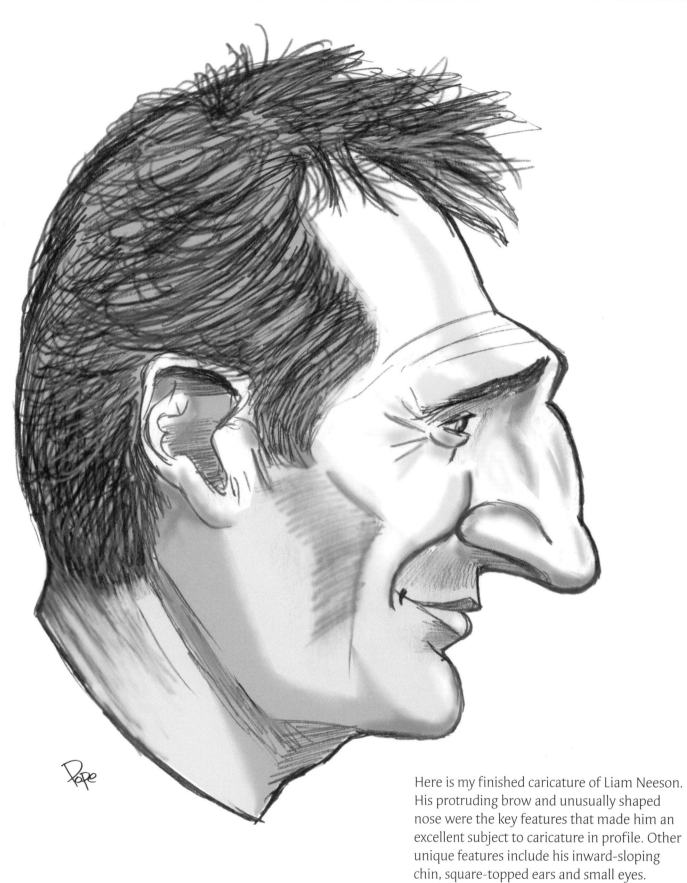

Here is my finished caricature of Liam Neeson. His protruding brow and unusually shaped nose were the key features that made him an excellent subject to caricature in profile. Other unique features include his inward-sloping chin, square-topped ears and small eyes.

Drawing a caricature in three-quarter view

The three-quarter view is probably the preferred angle for most caricaturists, since from this angle you can portray a better overall representation of your subject's facial characteristics. Not only can you show how far their ears protrude but also their nose as well, something you would struggle to do face-on or in profile.

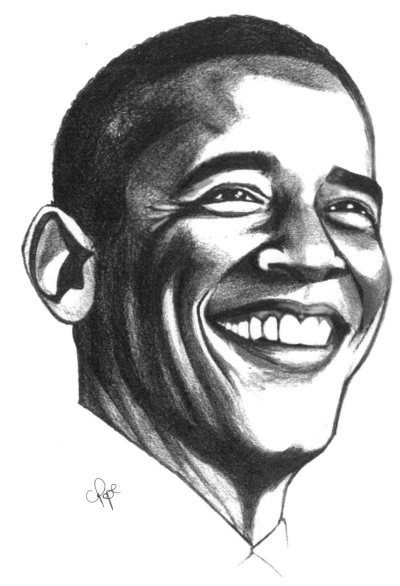

This is a pencil portrait of Barack Obama, President of the United States. It is an accurate likeness to the photograph the artist used for reference and serves as a good starting point for my caricature, backed up by a selection of photographs from various angles.

This is my preliminary outline sketch. After looking at my reference photos I decided to exaggerate the size of his mouth and chin and the protrusion of his ears.

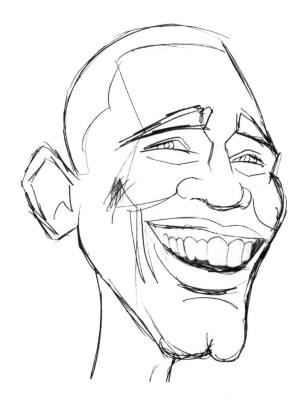

The same sketch has now been taken a little further. I have added the hairline and the raised eyebrows and sketched in the teeth, leaving a large section of gum on display. I have also put in the structure of the cheekbones and the flesh beneath and above the eyes.

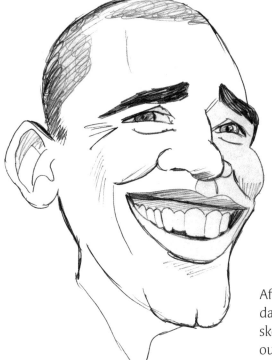

After adding a little pencil shading and darkening the eyebrows, I now have a sketch that is beginning to resemble our subject.

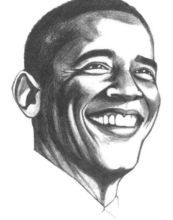

In reality, the ear I have now added on the right-hand side of the face wouldn't be visible as it would be hidden by the subject's cheek. However, it was essential to the overall look of the caricature.

From this angle, about half of the face will often be in shadow. By applying some block toning you can add more realism to your caricature, giving it an almost three-dimensional look that lifts it off the page.

Strange as it may seem, if I have done my job effectively my finished caricature (opposite) should be even more recognizable as Barack Obama than this portrait sketch – even though in real life the size and layout of his features would be a much closer match to the portrait. By amplifying your subject's unique facial features you will make them unmistakable and larger than life.

The main characteristics essential to the success of this caricature were a big, wide smile exposing bright teeth and a large section of gum; thick, dark eyebrows raised towards the middle of the forehead; protruding ears and a strong, protruding jaw; and an upright, slightly superior yet friendly posture.

Caricature by head shape

Some caricaturists start by drawing the main facial features of their subject, adding the head shape afterwards. However, others prefer to sketch out a rough idea of the head first and put in the features afterwards. If you decide to take this approach, it's important to ascertain the shape of your subject's head at the outset.

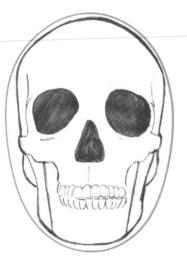

Viewed face-on, the average human skull is fairly close to an oval shape. However, the shape of the head can alter quite dramatically from one person to another depending on how the muscle, fat and skin tissue are distributed around the face.

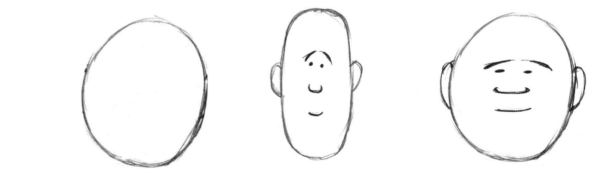

At first glance these odd shapes don't bear much resemblance to the human head, but as you can see, once a simple face and a pair of ears are added they take on a different form.

 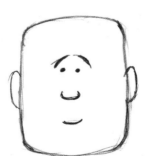

★★

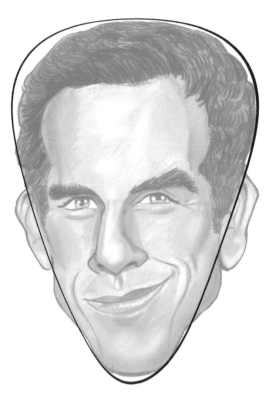

A line drawn around the basic shape of my caricature of Ben Stiller shows that his head is close to triangular.

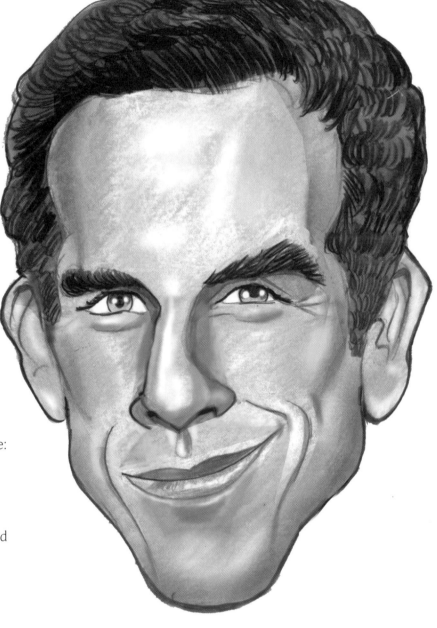

In the final caricature, you can see the unique characteristics that echo this head shape and that make the actor recognizable:

• his head is wider than average across the top, accentuated by his hairstyle

• the bottom of his left eye is partly covered by flesh, caused by his distinctive smile

• the bridge of his nose is wide and his ears protrude

• his smile rises higher on the left than the right and his chin is narrow.

CARICATURE BY HEAD SHAPE: STEP-BY-STEP

My caricature of Queen Elizabeth II has the opposite head shape to the one of Ben Stiller – it's wider at the base than at the top. As it's drawn from a three-quarter angle, I had to establish this in my basic head shape.

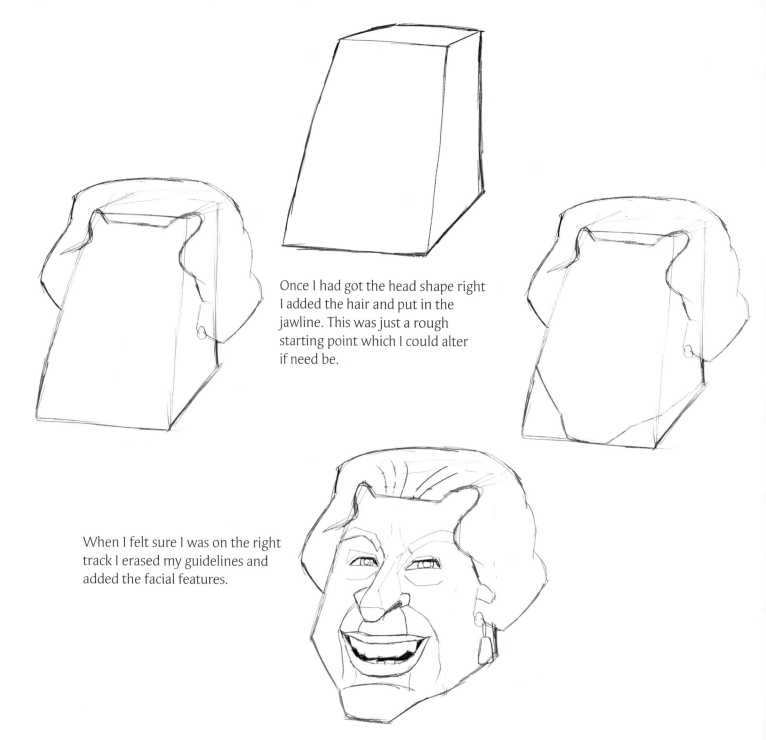

Once I had got the head shape right I added the hair and put in the jawline. This was just a rough starting point which I could alter if need be.

When I felt sure I was on the right track I erased my guidelines and added the facial features.

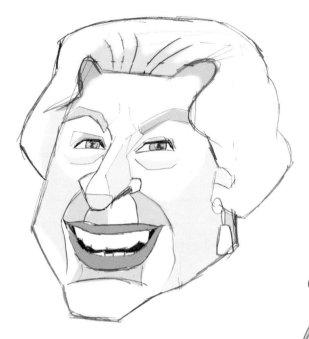

With some light tone added, my caricature began to take on some resemblance to the subject – certainly a good enough draft to start my final piece from.

The final caricature shows how I emphasized the unique features that make the subject immediately recognizable:

• her face is broader towards the base

• there is a larger than average space between her nose and top lip

• the flesh above her top lip is full and pronounced

• her short chin juts forward

• her nostrils are flared

• her eyebrows are fairly thick

• her hairstyle is unusual.

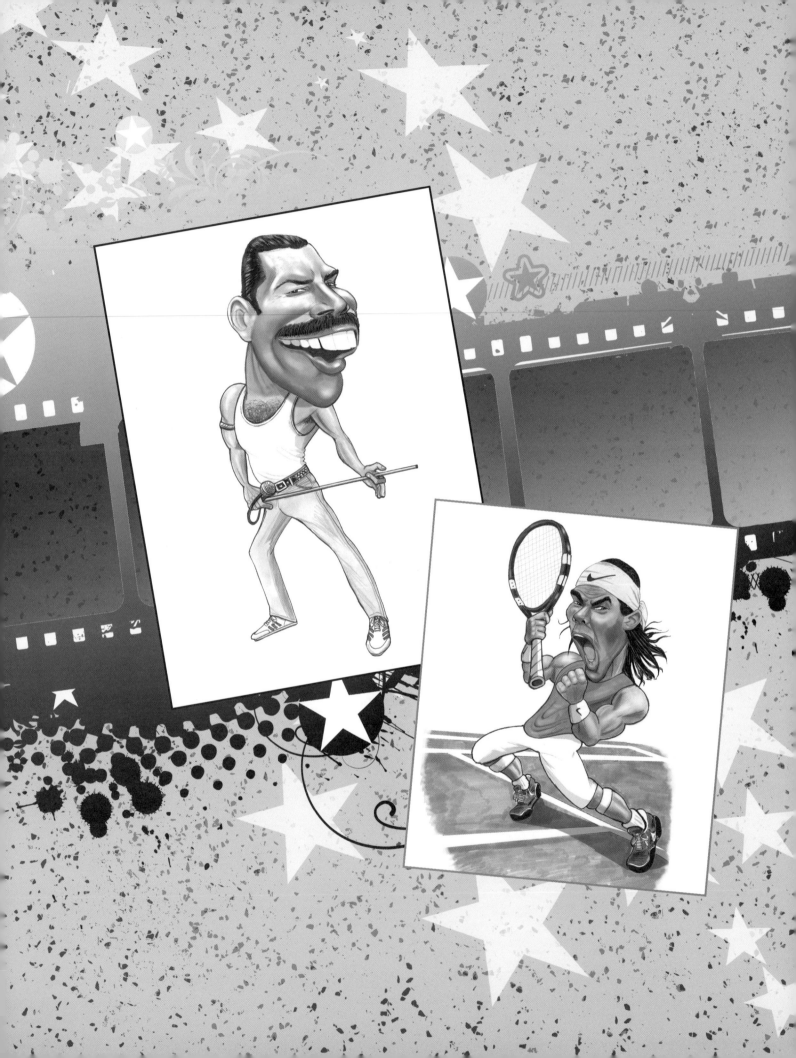

CHAPTER 3

★ *Full-figure Caricatures*

You can bring a lot to your artwork by adding a body, even if the main focus is on your subject's head and facial features. The posture, clothing and props you choose will all help to enhance the likeness to your chosen celebrity — and allow you to show them doing what they do best: singing, dancing, acting or playing sport. In this chapter we look at some of the possibilities of full-figure caricaturing, starting with basic proportions and ending on a 'celebrity couple' feature.

Proportions of the body

Although caricaturists generally focus on their subjects' facial features, the heads we are drawing often need a body to accompany them – so it's important we have an understanding of the proportions of the human figure to enable us to draw them effectively. This subject is briefly covered here, but I strongly recommend you read a good book on human anatomy if you want to take this aspect of your drawing further.

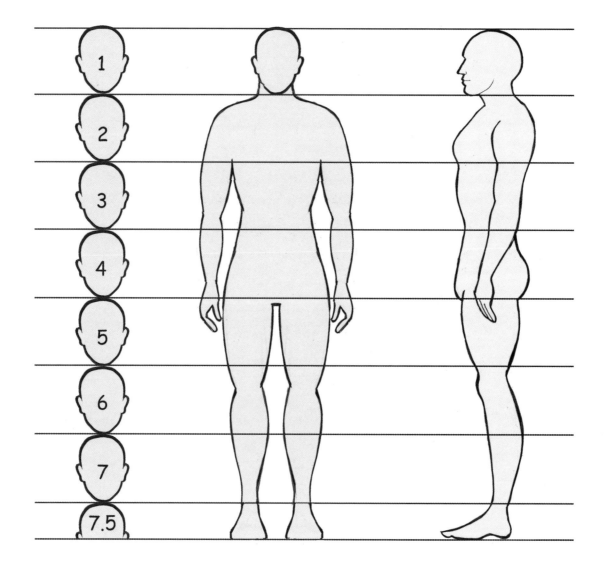

The above illustration is of the average adult male, shown both from the front and the side. As you can see, he stands approximately 7.5 heads high. It's important to remember that this is just a point of reference and proportions from one person to another may differ significantly.

★★★

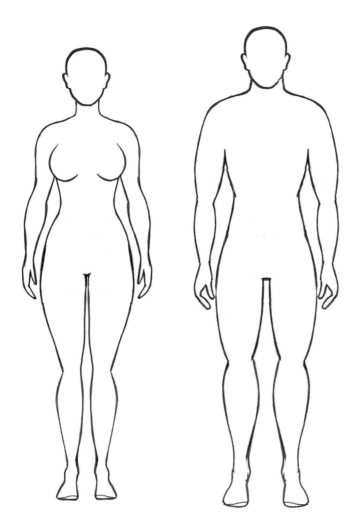

The average woman's body does not differ from that of a man in terms of head size in relation to overall height. However, on average a woman is generally shorter than a man, with proportionally narrower shoulders and broader hips.

Viewed from the side, a woman's breasts and more pronounced buttocks account for the main visual difference between the sexes. The male form, whether viewed from the side or the front, is less curvaceous than that of the female.

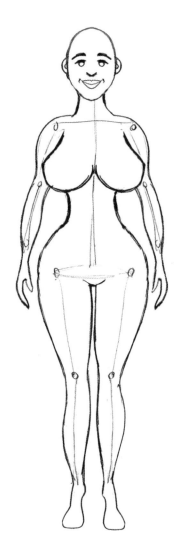

Caricaturing the body is no different from caricaturing the face in terms of the approach you need to take; as before, establish what is unique about your subject then exaggerate those elements. The illustration to the left is a caricature of the female form seen from the front. The body characteristics that define the figure as female have been exaggerated to excess, giving her disproportionately large hips and breasts.

This illustration is a caricature of a middle-aged male viewed from the side. Unlike women, men tend to put on most of their weight around the waist rather than the hips. Through lack of exercise, their legs tend to become skinny and their buttocks shrink. As with the illustration above, I have exaggerated the elements that define the gender of the figure. However, if your male subject were skinny or a female had small breasts you would find another part of their anatomy that was worthy of exaggeration.

The caricature sketch to the right has all the elements of the typical tough guy, with a narrow waist and huge shoulders, biceps and pectorals. The neck is so thick it's the same width as the waist.

This illustration displays all the body proportions of a glamour model, exaggerated to extreme – large, uplifted breasts, long slim legs, a slender neck and a tiny waist.

Body posture and movement

You can tell a lot about an individual by observing their body posture. You don't need to see their facial expression to gain an insight into their personality and emotions.

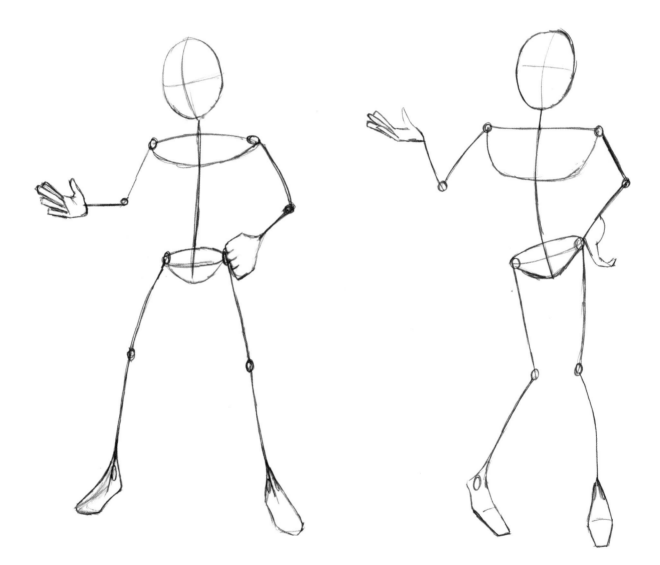

Body postures send out many signals, including the masculine or feminine tendencies of an individual. For example, the figure to the left displays a masculine body posture and the one to the right looks more feminine. However, don't make obvious assumptions when you draw a subject, since either gender is capable of adopting masculine or feminine poses – there are many male celebs who are either gay or act in a slightly camp fashion, for example. Study your subject's body posture carefully, get it right and it will help you to achieve a great resemblance and ultimately a great caricature.

★★★

MUSICAL ENTERTAINERS AND BODY POSTURE

A fair percentage of celebrities are musical entertainers, and for this particular breed of performers it's important that not only is their sound distinctive but also their act. Therefore, it's paramount that they establish a set of movements, postures and gestures that set them apart from other acts – and this means they usually make great subjects to caricature.

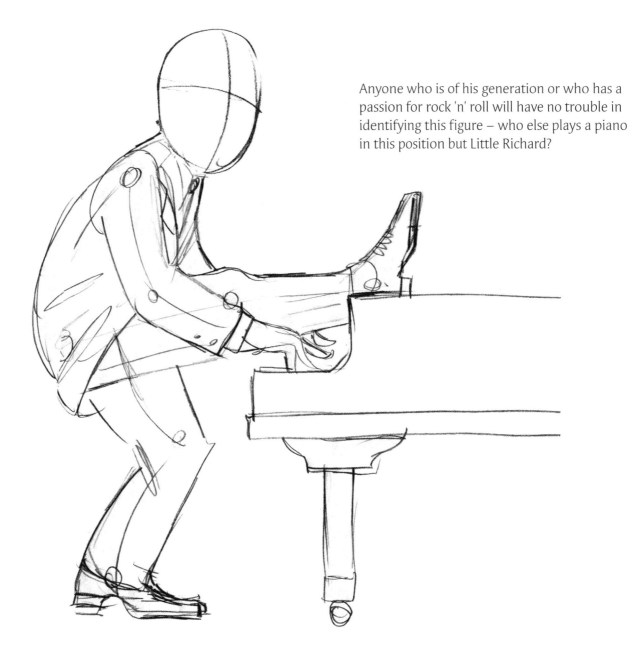

Anyone who is of his generation or who has a passion for rock 'n' roll will have no trouble in identifying this figure – who else plays a piano in this position but Little Richard?

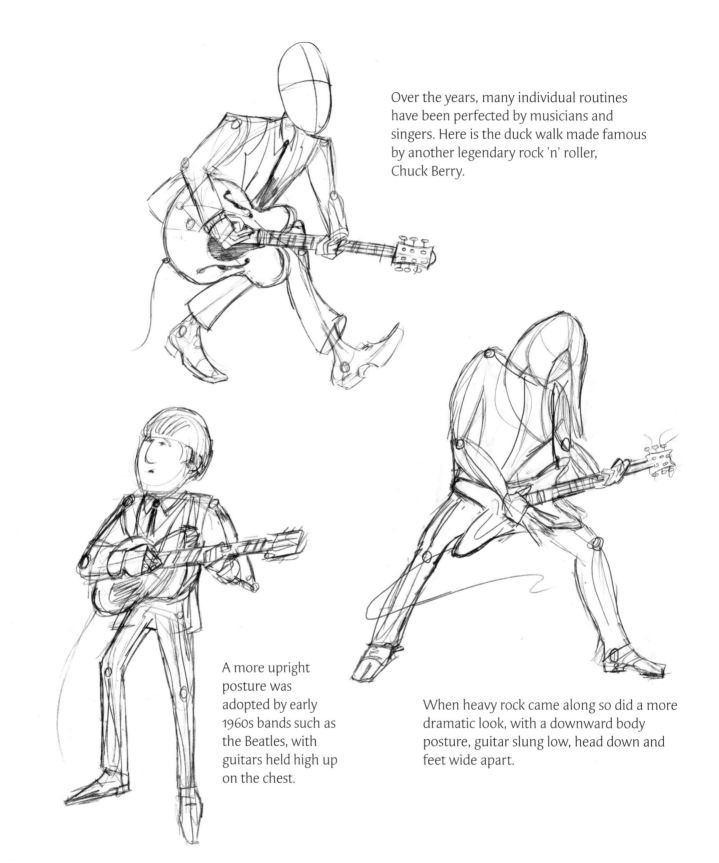

Over the years, many individual routines have been perfected by musicians and singers. Here is the duck walk made famous by another legendary rock 'n' roller, Chuck Berry.

A more upright posture was adopted by early 1960s bands such as the Beatles, with guitars held high up on the chest.

When heavy rock came along so did a more dramatic look, with a downward body posture, guitar slung low, head down and feet wide apart.

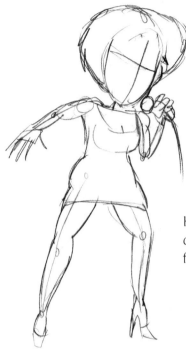

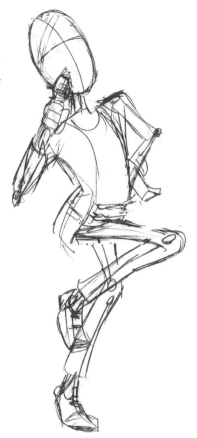

When Mick Jagger performs, his body posture and movements look somewhat camp.

Here is a rough sketch of the quite masculine body posture favoured by Tina Turner.

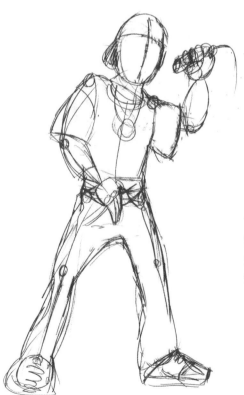

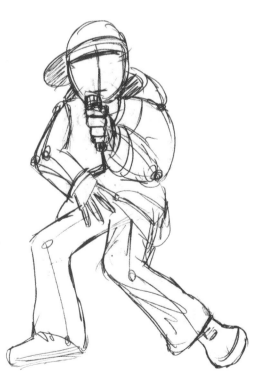

These two sketches illustrate postures and moves that are specific to today's rap artists.

A PERFORMER FROM DRAFT TO FINISHED ARTWORK

There were so many immediately recognizable characteristics to the late great Freddie Mercury. His use of body posture was certainly one of them, and the way he used his mike stand to imitate playing a guitar was something I wanted to include in caricature.

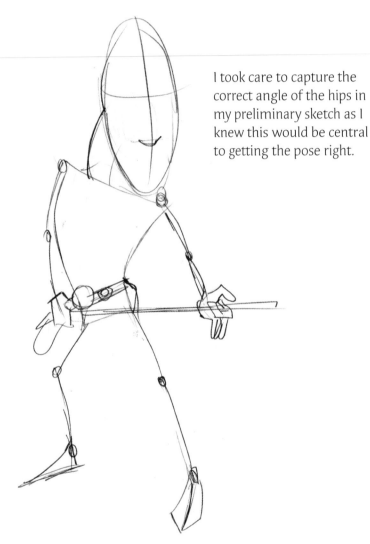

I took care to capture the correct angle of the hips in my preliminary sketch as I knew this would be central to getting the pose right.

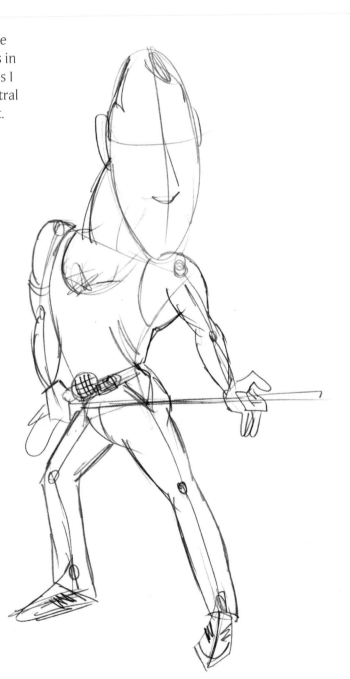

Reasonably happy with the body posture and composition of the framework sketch, I moved on to fleshing out and clothing my subject. This was now sufficient to use as a base for the body of the caricature artwork opposite.

When he was on stage, Freddie Mercury's body language oozed with confidence and charisma. He was a superb subject to caricature for this section. Because he was a larger-than-life character I chose to caricature his features to extreme – for more on extreme caricaturing see pages 106–9.

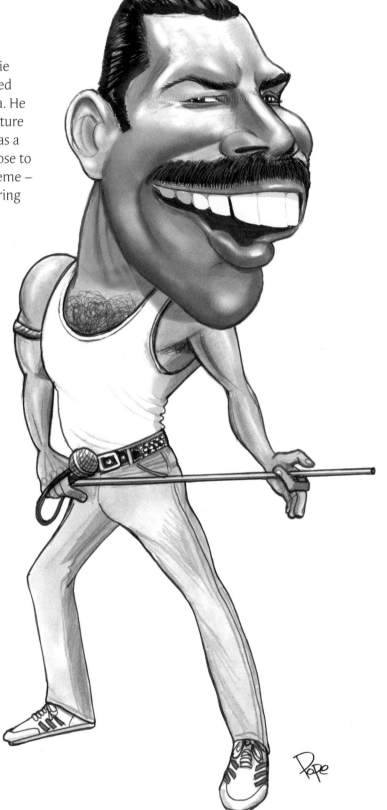

SPORTSPEOPLE AND BODY POSTURE

Body posture doesn't get any more dynamic than that displayed by some of the top sports celebrities of our time. When the brilliant tennis player Rafael Nadal scores a crucial winning point his relief, grit and determination are dramatically expressed in the form of an extreme body posture.

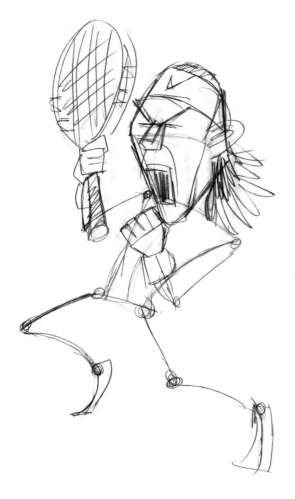

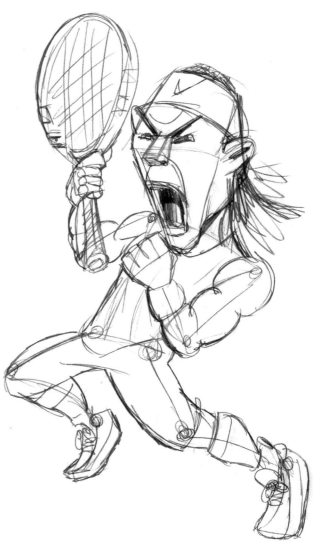

Using the same process as on the previous pages, I drew my first preliminary sketch as a loose framework to capture the posture and movement I desired.

Once I was happy with my framework drawing I fleshed out and clothed my subject, adding plenty of muscle formation around the arms. This sketch was used as a base for the body of the finished caricature opposite.

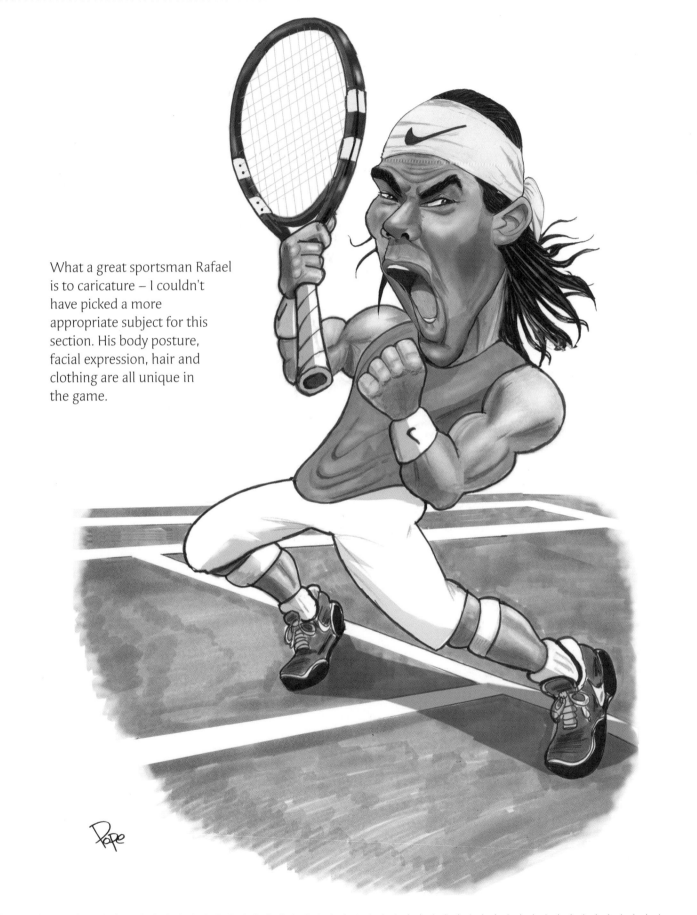

What a great sportsman Rafael is to caricature – I couldn't have picked a more appropriate subject for this section. His body posture, facial expression, hair and clothing are all unique in the game.

Red-carpet poses

Top celebrities are often invited to attend red-carpet events such as award ceremonies and film premieres. Knowing that when they arrive they will be in front of a battery of cameras, they dress and pose accordingly.

If you study photographs of your subjects you will find they often favour a particular pose. The sketch of this couple is drawn from a photograph of David and Victoria Beckham.

In this sketch, Victoria is in a similar pose to that above; one leg in front, hands on hips, shoulders back and head tilted slightly downward. Even with no added details, she is probably recognizable to anyone who takes an interest in celebrities.

This elegant pose was sketched from a photograph of Renée Zellweger attending a red-carpet function.

★★★

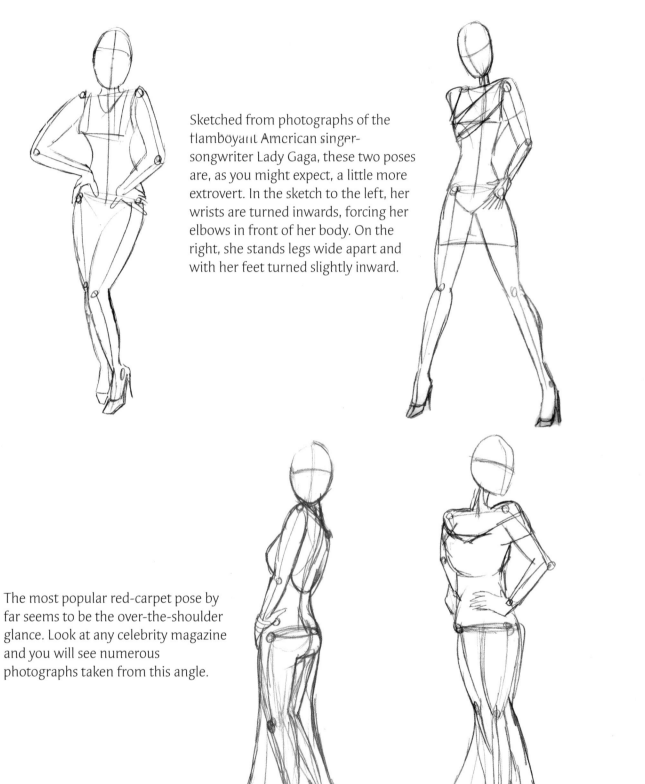

Sketched from photographs of the flamboyant American singer-songwriter Lady Gaga, these two poses are, as you might expect, a little more extrovert. In the sketch to the left, her wrists are turned inwards, forcing her elbows in front of her body. On the right, she stands legs wide apart and with her feet turned slightly inward.

The most popular red-carpet pose by far seems to be the over-the-shoulder glance. Look at any celebrity magazine and you will see numerous photographs taken from this angle.

RED-CARPET POSES: OSCAR QUEEN

I decided to caricature Meryl Streep, one of the most celebrated movie actresses of our time, and the first step was to come up with a suitable posture. This preliminary sketch captures the pose I was looking for – one hand on hip and the other proudly holding the Oscar aloft.

The next stage was to flesh out the body and then drape the long flowing dress over the top. Of course you could just draw the outline of the garment from the outset, but I find that drawing the framework of the body first helps to establish the correct posture.

★★★★☆ **STAR TIP** ★★★★★

Use perspective to enhance the body proportions of your celebrity: drawing from above will make your subject appear shorter, while drawing from below will accentuate height and mimic the red-carpet angles favoured by paparazzi.

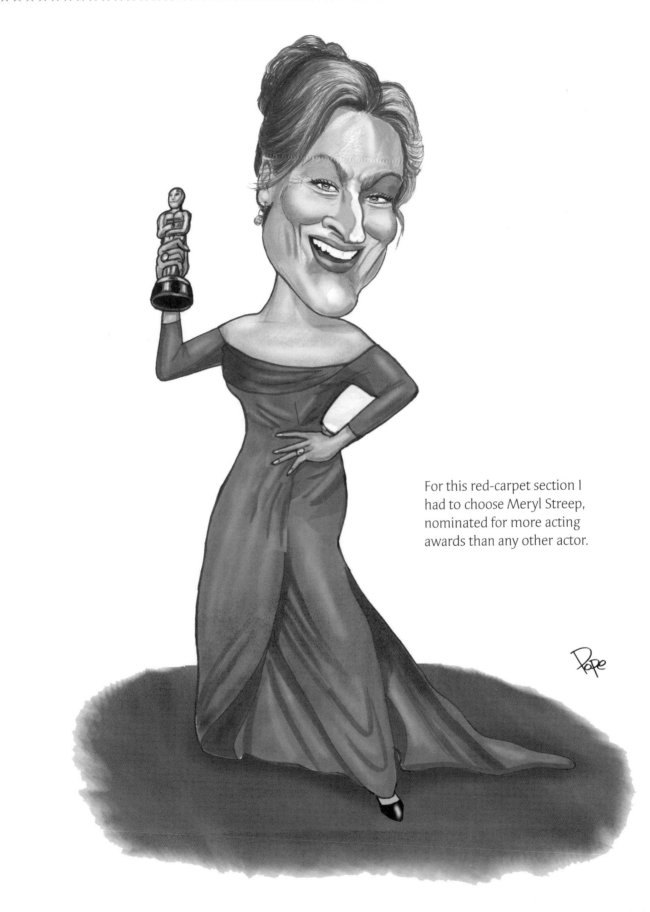

For this red-carpet section I had to choose Meryl Streep, nominated for more acting awards than any other actor.

Props and clothing

When props and clothing are used effectively, they alone can make a very average celebrity caricature recognizable. However, don't fall into the trap of illustrating props and clothing as a substitute for working on your caricaturing skills – use them to enhance an already successful caricature with humour and realism.

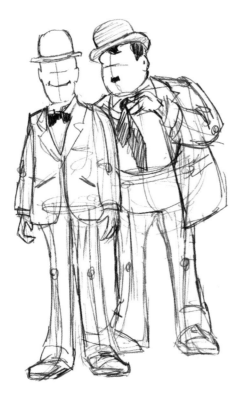

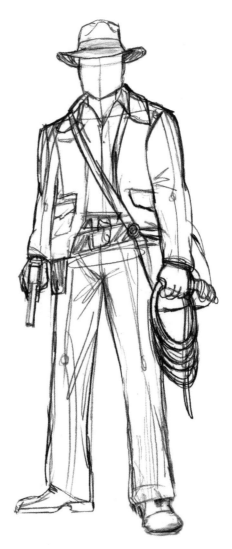

The body posture and shape help in the identification of this comedy duo, but it's their clothing and how it's worn that make them unmistakably Laurel and Hardy.

In this sketch the body and posture are unremarkable – it's the clothing and selection of props that leave no doubt that you are looking at film star Harrison Ford in character as Indiana Jones.

Many cowboy characters have been represented over the years, but there was only one who wore a poncho draped over his shoulder. The spaghetti westerns gave birth to 'the man with no name', played by legendary movie star and director Clint Eastwood.

Body posture plays a big part in identifying who this celebrity is, but it's the dress and the invisible prop – the upward gust of air – that act as an instant identifier of 1960s movie star and blonde bombshell Marilyn Monroe.

I'm sure that with this array of clothing and props you'll have no problems identifying Captain Jack Sparrow, played by Johnny Depp in the *Pirates of the Caribbean* films.

These two men are both dressed in suits and holding guns. While their very different body posture helps to distinguish them from one another, it's the style of suit, boots, shirt, glasses and hair that make the far right figure unmistakable as character Austin Powers, played by comedy actor Mike Myers. The other, of course, is Bond – James Bond.

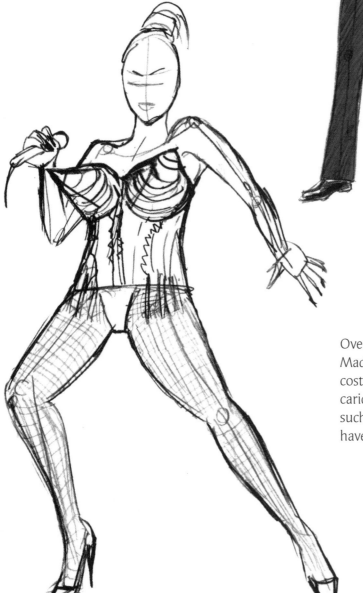

Over the years, singer and movie actor Madonna has worn some outrageous stage costumes. If the celebrity you decide to caricature has a habit of wearing bizarre outfits such as the one illustrated in this sketch, then have some fun by exaggerating their quirkiness.

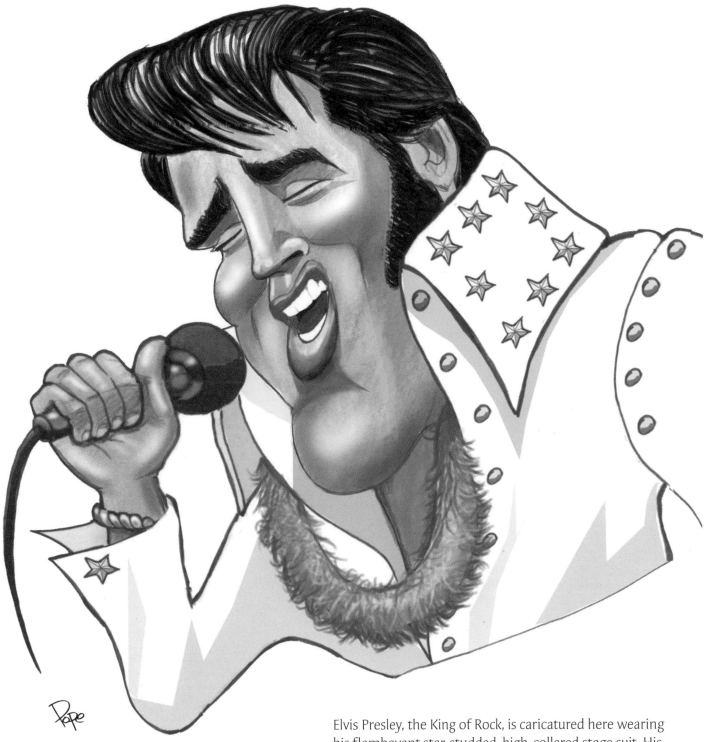

Elvis Presley, the King of Rock, is caricatured here wearing his flamboyant star-studded, high-collared stage suit. His hairstyle, unique facial features and expression gave me plenty to work with, but to complete the caricature the right choice of props and clothing made all the difference.

CELEBRITY COUPLE

When it comes to celebrity couples there are plenty to choose from, but unfortunately few stand the test of time. With that in mind, when it came to choosing the ideal couple for this feature I chose a couple I believed would still be together many years hence. Who better than Sharon and Ozzy Osbourne, who have been married for nearly thirty years already?

★ When taking on a complicated caricature that includes more than one person as well as props, it's worth spending time on some preliminary sketches. This is my first rough pencil draft. At this stage all I wanted to do was lay down the basic composition of the props and figures involved.

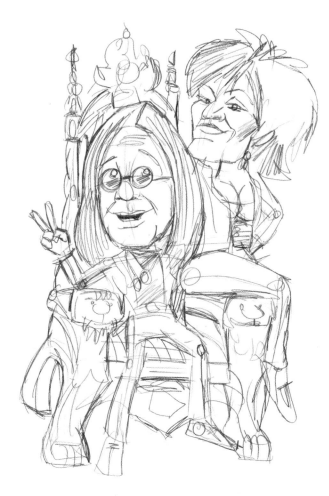

★ Using the previous draft as a basic layout reference I drew a second sketch, this time adding more detail to the couple's faces and clothing. Although this sketch is still quite loose it contains individual facial expressions, body postures and gestures – the key elements for the final artwork.

★ One of the reference photos I used featured Ozzy sitting on a large wooden throne elaborately decorated with intricate carvings. To help me get the dimensions right, I drew the throne on its own. Details from this drawing could then be traced into my final piece.

★ Using a light box, I traced some of the work from my previous sketches to produce this draft for my final piece. I changed a few things on the way, such as the angle of Ozzy's legs and the width of his trousers. I also altered the position of his head so that he was looking toward the viewer.

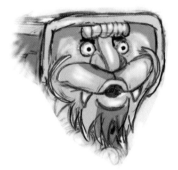

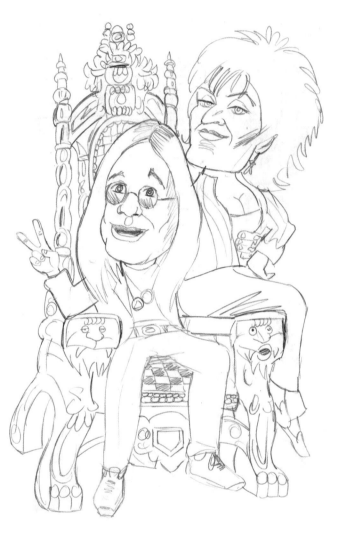

★ If you can add a little humour to the props, so much the better. The two illustrations above and below are from the carved faces on the front of the throne arms. They should be identical, but I decided to create a winded expression on the one beneath Sharon – a little cheeky, but all in good fun.

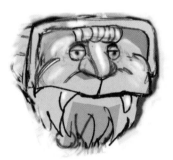

★ The decorative carpet and elaborate throne serve as a great backdrop for the finished piece of artwork. It's always key to capture the subjects' unique facial characteristics, but the attention paid to the overall composition along with the body postures and gestures help to make this caricature successful.

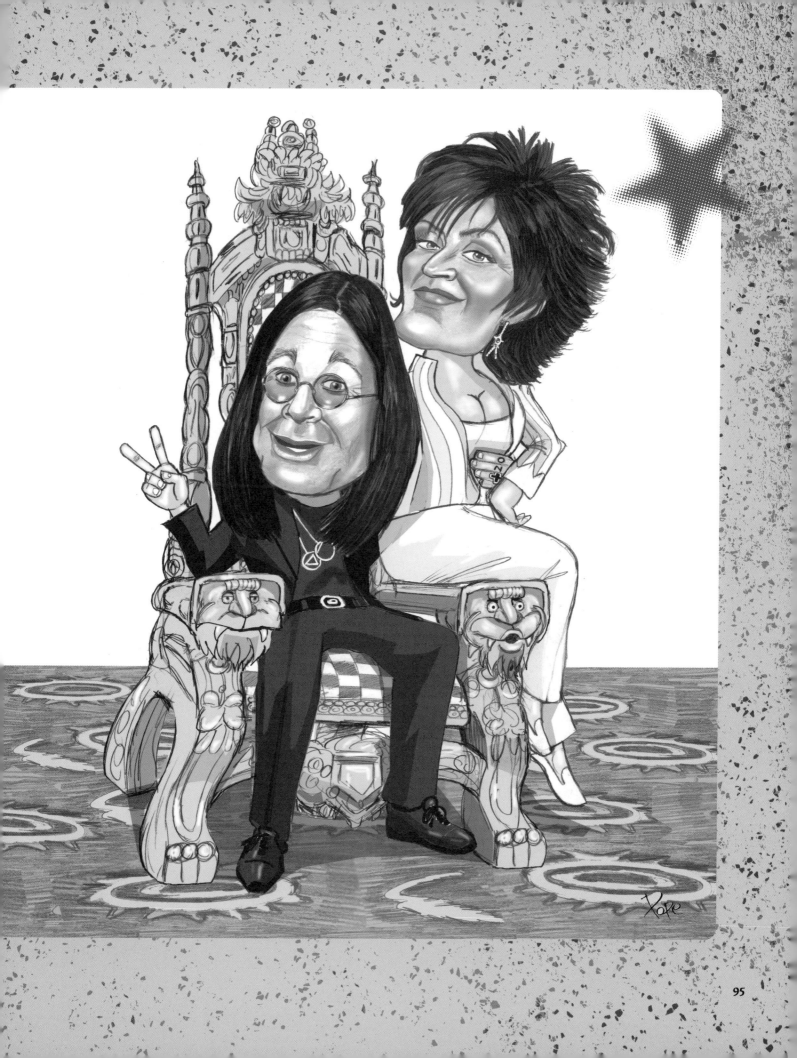

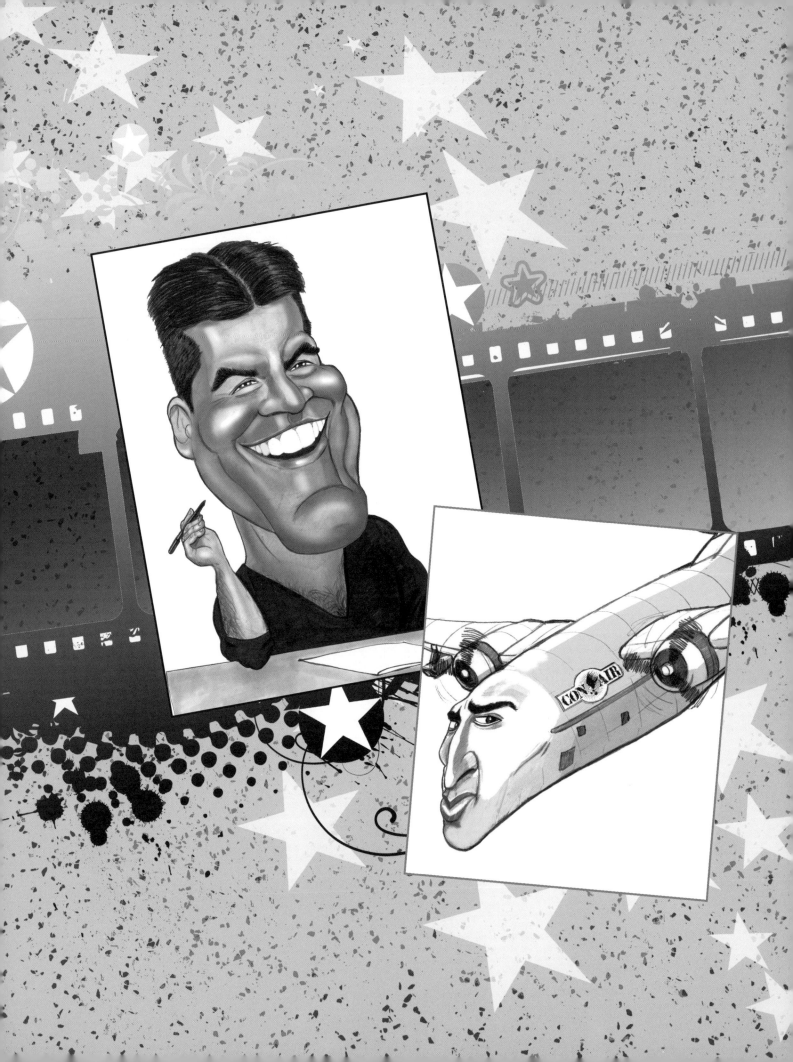

CHAPTER 4

★ Creative Caricaturing

Now that we have looked at creating classic head and full-figure caricatures, you can try your hand at adding an inventive spin to your artwork. Anthropomorphism is a wonderful way to add that extra touch of humour to your celebrity and there are no limits to what you can draw, save for your own imagination. We'll also take a look at how you can take your caricature to extreme, experiment with different styles and techniques, and make the most of computer technology to enhance your artworks.

Anthropomorphism

If you want to test your expertise and creativity as a caricaturist, anthropomorphism is a great way of doing so. To be able to represent an individual's facial characteristics on an inanimate object or a different species takes probably more skill than any other form of caricaturing. There are different variations of anthropomorphism, some a lot easier than others. The simplest is to merge the head of your subject on to the body or object that is relevant to your caricature.

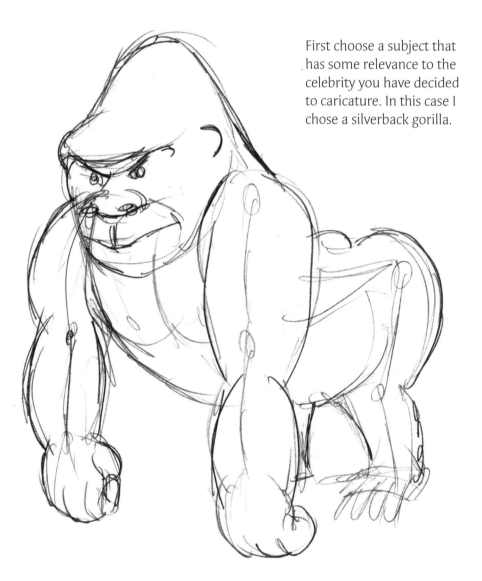

First choose a subject that has some relevance to the celebrity you have decided to caricature. In this case I chose a silverback gorilla.

★★

Once happy with the proportions and posture, I erased the gorilla's head and replaced it with a caricature of my chosen celebrity.

Here is my finished caricature of the American movie star Mark Wahlberg portrayed as a silverback gorilla. Apart from the obvious connection of Wahlberg playing the lead role in the movie *Planet of the Apes*, his muscular physique and the deep facial frown make him an ideal celebrity for this piece of anthropomorphism.

Taking the anthropomorphism process a stage further, I chose a rhinoceros – a species that bears no resemblance at all to our own, which makes this caricature far more of a challenge than the gorilla on the previous pages.

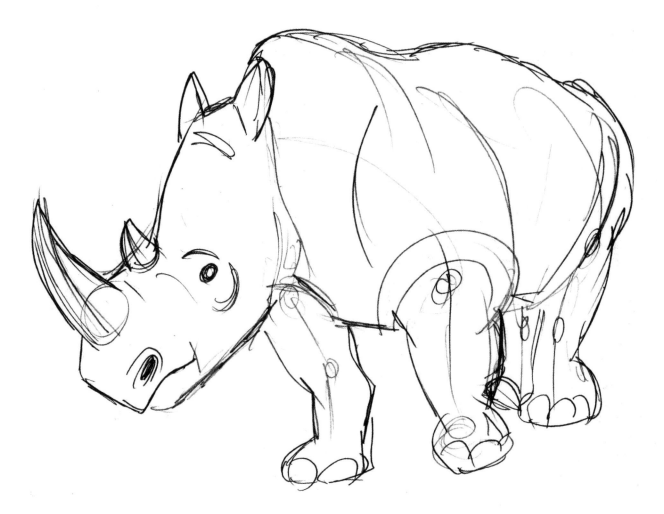

This time the shape and position of the subject's facial features would have to be drawn in such a way that they conformed to the shape of a rhinoceros head – plus I had a horn to contend with!

The next step was to choose a celebrity who was renowned for being incredibly strong and powerful. A young Mike Tyson would do the trick.

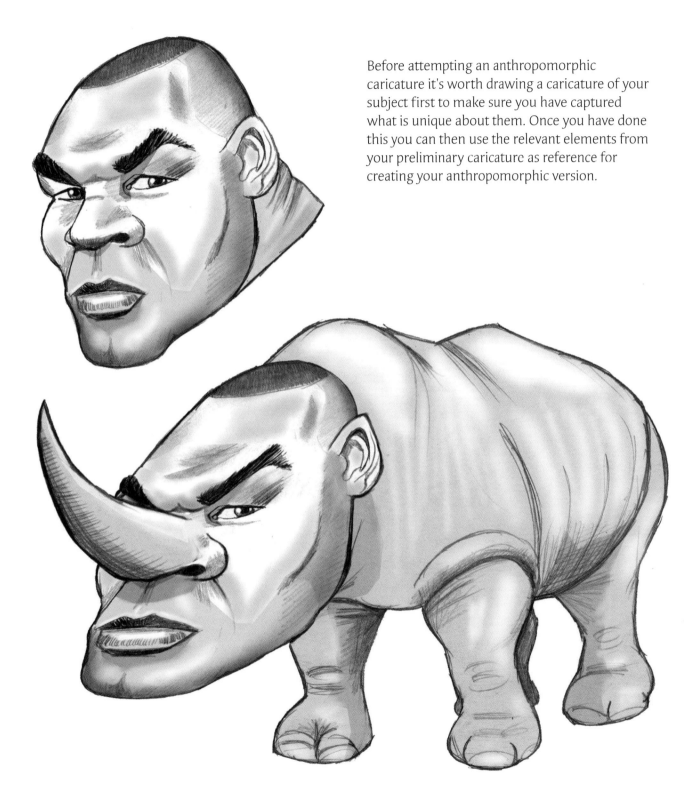

Before attempting an anthropomorphic caricature it's worth drawing a caricature of your subject first to make sure you have captured what is unique about them. Once you have done this you can then use the relevant elements from your preliminary caricature as reference for creating your anthropomorphic version.

Admittedly, in this caricature the resemblance to Tyson doesn't jump off the page. However, considering that his nose has been replaced by a horn, his ears are at the top of his head and the basic shape of the head is nothing like that of a human, to accomplish any resemblance was an achievement. If you can see a resemblance it will be down to the eyes, eyebrows and hairstyle.

★★

Here we have an older, heavier Mike Tyson caricatured as a
hippopotamus – another strong, fierce creature, but with a
very different head shape. I deliberately chose to caricature
the same subject to demonstrate that it's possible to find
something unique and distinguishable in your subject that
will be recognized no matter what form they take.

The facial tattoo, the eyes and eyebrows and the gap
between the front teeth, two of them gold, all add up to this
fairly successful anthropomorphic caricature.

★★

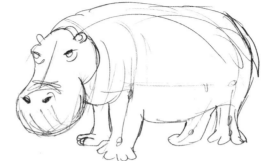

These two images were sketched from photographs I found surfing the web. The sketch immediately above is the one that I favoured, but I had to adapt the angle for the final artwork or the subject's facial features would have been hidden from view.

Anthropomorphism can be used with inanimate objects as well as animals. Means of transport such as planes, boats and trains make great subjects to use. For this next anthropomorphic celebrity caricature I chose the American movie star Nicholas Cage, who starred in the 1997 movie *Con Air*.

This is the sketch I drew from reference photographs of the plane featured in the film, minus details of the cabin as this would eventually be replaced with the actor's face.

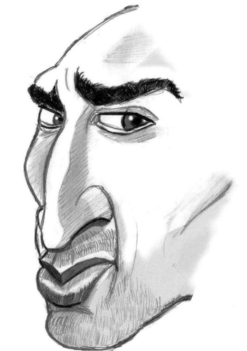

This was my first attempt at caricaturing Cage. It's not quite right, but the resemblance was good enough to make a start from. Make sure you draw your caricature at the correct angle so that when you eventually combine the two drawings they match up.

Here is the end result: movie star Nicholas Cage caricatured as the plane from *Con Air*.

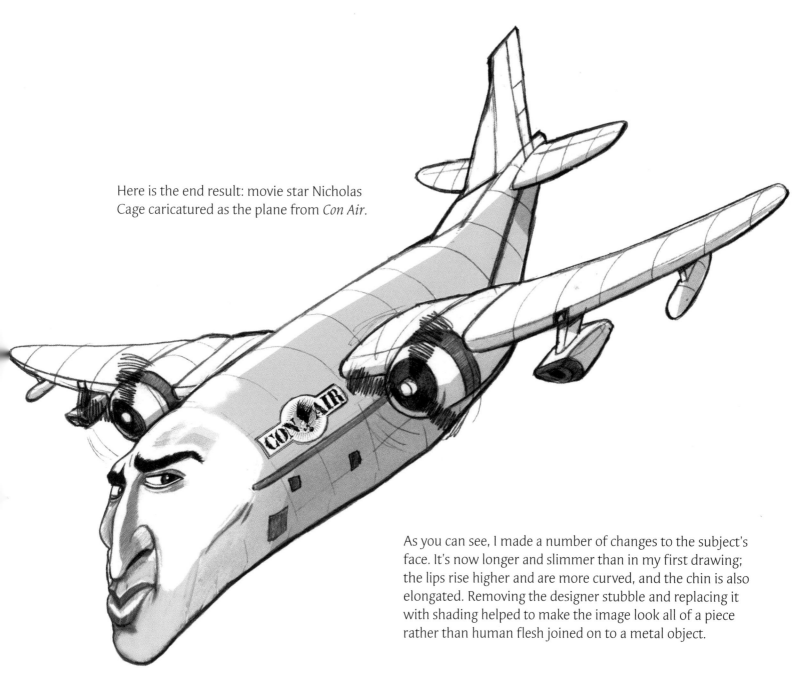

As you can see, I made a number of changes to the subject's face. It's now longer and slimmer than in my first drawing; the lips rise higher and are more curved, and the chin is also elongated. Removing the designer stubble and replacing it with shading helped to make the image look all of a piece rather than human flesh joined on to a metal object.

The overall shape of the plane's nose also had to change or it would never have resembled the actor. With this type of caricature you need to make a compromise between one subject and the other until you reach a successful middle ground. It can be difficult and a lot of trial and error may be involved, but with practice it becomes easier.

Extreme caricatures

Certain celebrities have something about their character or facial features that begs you to caricature them to the extreme. It's possible to do this with any celebrity, but I am usually most tempted when either their personality or their features are larger than life.

Television personality and talent-show judge Simon Cowell was an ideal candidate for this type of caricature. Although none of his features is particularly large or unusual, his on-screen character and temperament certainly are.

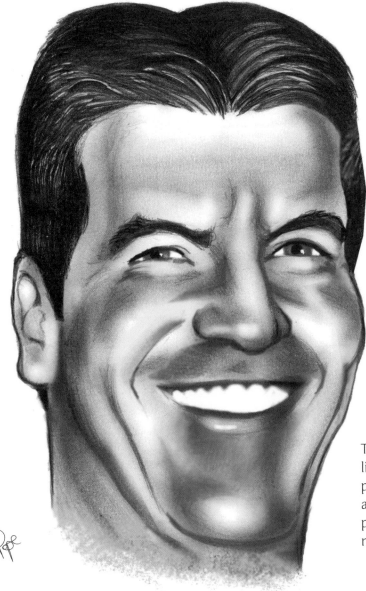

The above portrait is a good likeness of the reference photograph used by the artist. I used this photograph along with many others as reference.

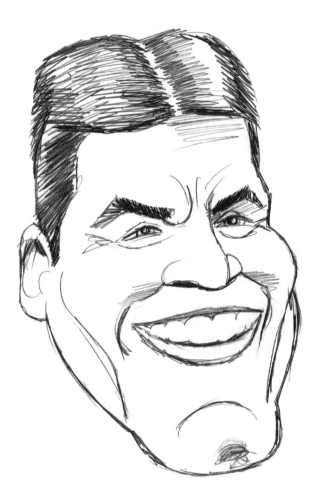

This was my first pencil sketch – not a great resemblance at this stage, but as a starting point it would suffice.

With more detail added to the eyes, dark tones in the hair and some shading around the face, the sketch started to come to life. With the addition of the raised cheek muscles and smile, I now had the makings of a reasonable caricature.

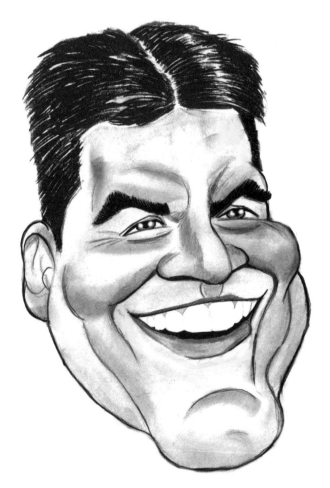

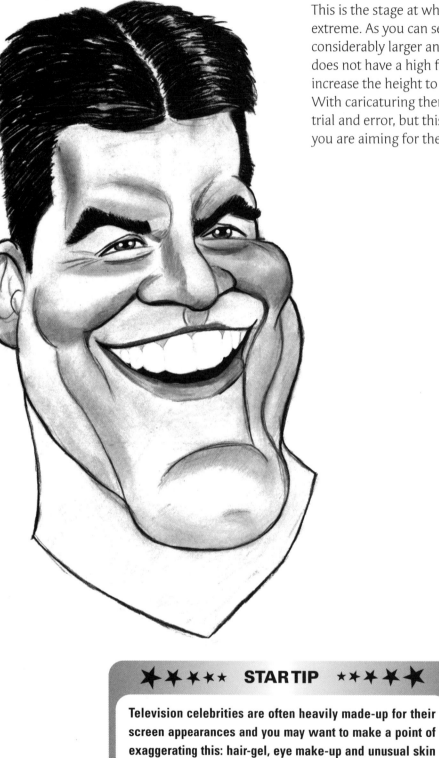

This is the stage at which the caricature became extreme. As you can see, I have made the chin considerably larger and longer. Although Simon does not have a high forehead I felt the need to increase the height to counterbalance the chin. With caricaturing there is always a fair amount of trial and error, but this is even more the case when you are aiming for the extreme.

★★★★★ **STAR TIP** ★★★★★

Television celebrities are often heavily made-up for their screen appearances and you may want to make a point of exaggerating this: hair-gel, eye make-up and unusual skin tone are all things to look out for.

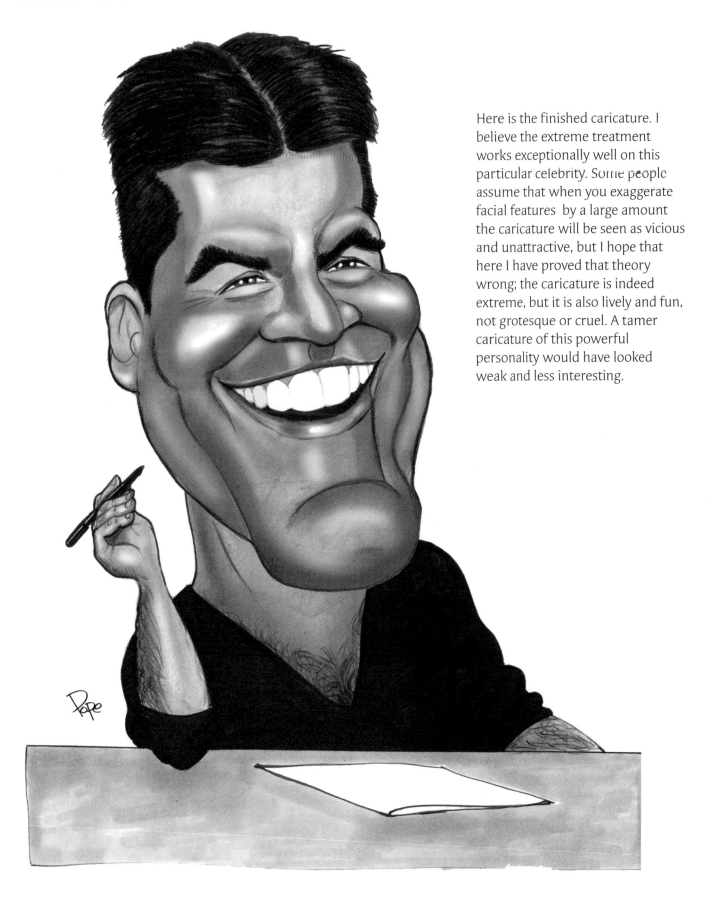

Here is the finished caricature. I believe the extreme treatment works exceptionally well on this particular celebrity. Some people assume that when you exaggerate facial features by a large amount the caricature will be seen as vicious and unattractive, but I hope that here I have proved that theory wrong; the caricature is indeed extreme, but it is also lively and fun, not grotesque or cruel. A tamer caricature of this powerful personality would have looked weak and less interesting.

Different styles and techniques

Caricatures can be approached in many styles and using a whole range of materials, and this choice makes the craft all the more interesting. Some caricaturists make incredibly detailed drawings or paintings; others get down a likeness in just a few marks – and both techniques can yield great results. It is a good idea to experiment with different styles and see which suits you best.

The brush-tipped pen is popular with caricaturists at live events as it's flexible and ideal to use at speed. The thickness of the line is determined by the angle at which you hold the pen and how much pressure you apply.

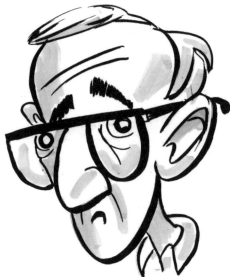

This caricature of Woody Allen was drawn using only a few lines of a brush pen, with no shading or rendering. It's very different to my usual style and I was only able to draw it successfully by studying the work of other illustrators and caricaturists. To capture a likeness with so few lines is no easy task.

Here is the same artwork with some added dabs of tone from a light grey marker pen. It's still a very simple drawing, but it has gained a little more depth.

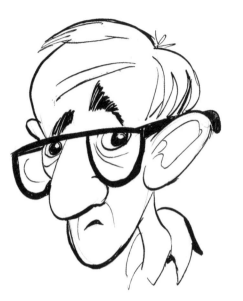

This sketch was drawn with a Gillot drawing pen and black Indian ink. Again the thickness of line is determined by the angle and pressure applied, but as you can see the lines are much finer and more detailed than those from the brush pen and they can be drawn thinly enough to produce excellent cross hatching. Using this type of pen achieves an authentic scratchy look quite different from any other medium.

Indian ink has a superb dark, dense quality. However, it can be a little frustrating as it takes a while to dry, so you need to be extra careful not to smudge your artwork.

Once it is dry you can add tone with a brush, using a lighter shade of ink or watercolours.

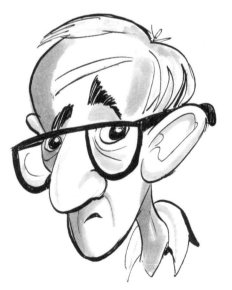

ONE SUBJECT, THREE STYLES

I was inspired to draw this caricature of Madonna in a rather unusual style after seeing some of the superb artwork produced by the extremely talented Argentinian artist Pablo Labato. I certainly wouldn't have been able to achieve a likeness in this style without studying some of Labato's work first.

This is another caricature of Madonna, again done in a different style to how I would normally draw. It looks completely different to the artwork above, yet both images are recognizable as Madonna.

Finally, a caricature created in my usual style. When compared to the two images on the facing page, it almost looks like a straight portrait. In fact I have exaggerated certain facial features and if you look at a photograph of Madonna you'll see that the artwork is without doubt a caricature – albeit a relatively tame one. All three images show completely different interpretations of the same subject.

The examples on these pages show just a few of the many different styles of caricaturing. As a beginner it's well worth experimenting with various styles to see which you feel most comfortable with.

Colour rendering in fine detail

Unlike the simple line caricatures on the previous pages, the caricature artwork featured here required the addition of tone and shading to bring it to life. My initial caricature of the British actor Hugh Laurie – in character as House from the TV series of the same name – was drawn using a black polychromos artist's pencil. The tone was added using computer software after scanning the image (see pages 118-23 for more on computer techniques), but it could have been done just as effectively by using a light grey marker pen.

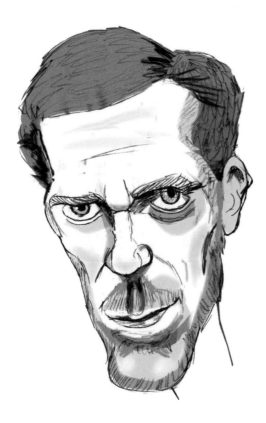

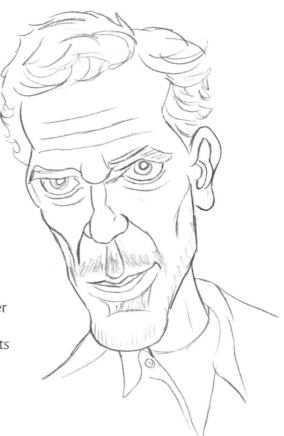

I traced my original drawing on to a sheet of Bristol board, using a terracotta-coloured polychromos pencil. Terracotta is an ideal colour as it's dark enough to show through the lighter skin tones and doesn't look out of place against them. As you can see, without the tone the traced image has lost much of its resemblance to my subject.

The next stage was to add a light skin tone across the face with one of my water-soluble artists' painting crayons. I then used my fingers to blend the crayon strokes into one another to achieve a smooth overall tone.

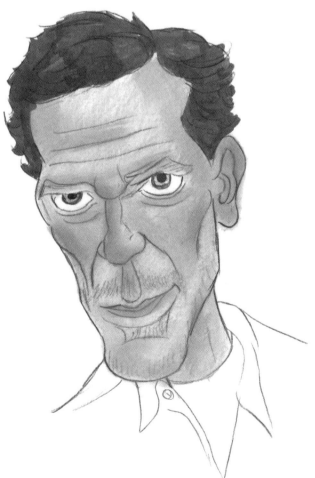

Using marker pens, I applied colour to the hair and eyes, making sure I chose lighter shades than those I would need for the completed artwork. I then introduced deeper-coloured skin tones using water-soluble painting crayons.

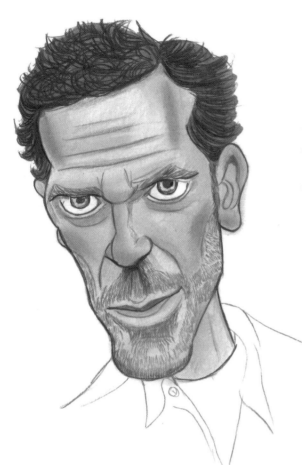

Now it was time to make use of the polychromos artists' pencils again, adding definition to the hair, eyebrows, designer stubble and facial features. It was at this point my artwork began to show a good likeness to our character once again.

I blocked in the clothing using coloured marker pens and drew around the outline using a 0.4 black fineliner pen. I then removed any smudging around the edges with a soft eraser. The caricature was now very close to completion.

Here is the finished caricature. Highlights on the skin were achieved by erasing some of the existing crayon work using a hard eraser on the end of a pencil. I also applied touches of white gouache to the eyes and shirt buttons. It's these small adjustments that will help bring your caricatures to life.

Using computer technology

Computer software offers artists a variety of tools to choose from, so I have embraced this new technology in my own work. Just like traditional tools, the software requires quite a bit of skill to use effectively, so be prepared to practise and have plenty of patience. Because there are so many different software programs available, here I will only cover the tools and techniques I find most useful.

One of the most important pieces of equipment you will need is a scanner. If you can afford it, buy an A3 scanner as this will allow you to scan larger artwork. They can be rather expensive, but if you shop around you can find them for about twice the price of a decent quality A4 scanner. To my mind they are well worth the extra investment.

A graphics tablet will allow you much finer control with your drawing tool than you will be able to manage using a mouse, so I strongly recommend you buy one. Nowadays you can pick these up relatively cheaply.

Most Photoshop software will have a range of brushes that will enable you to draw with various media effects such as charcoal, pencil, watercolour, marker pen, air brush and so on. With the aid of a graphics tablet it's possible to originate a digital drawing without going near a pencil and paper, but I prefer to use traditional methods and only turn to computer software to enhance my work.

★★

BLENDING SKIN TONE

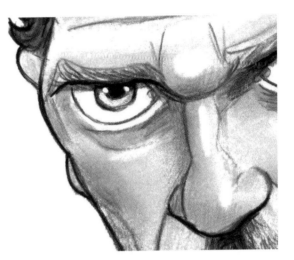

The image on the right is a detail from my Hugh Laurie caricature. All the rendering has been done to my satisfaction using traditional methods (see pages 114–7), but here I will make changes to the artwork using various software tools to illustrate their effects.

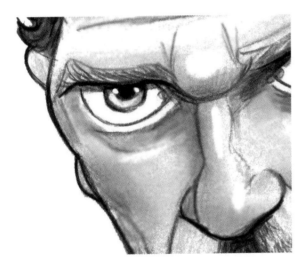

If you feel that some of your original crayon or pencil lines look a little too coarse, it's possible to soften them with the blend tool. Look closely at this detail and you will see that the lines beneath the eye and over the cheek have been blended together to create a more even tone.

In the Photoshop toolbox, the icon shaped like a raindrop is the blend tool.

ADDING TONE

To add extra shade or colour to a particular area of your artwork, use the lasso tool in polygon mode to select the area you want. In Photoshop, the polygonal lasso tool can be found by clicking on the freehand lasso tool, which has an icon like a noose. Using your graphics pen or mouse, click around the area until it is fully encompassed by a shimmering dotted line.

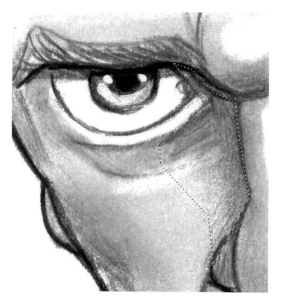

Here is the icon for the polygonal lasso tool.

The paintbrush icon is immediately recognizable.

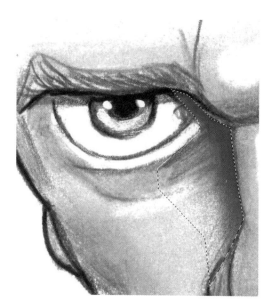

There are various choices of paintbrush in Photoshop, and here I chose the spraycan option. In most software programs you can alter the size of the brush, as well as opacity and flow. In Photoshop, spray the area you wish to cover, choose Select at the top menu bar then Deselect from the drop-down menu; the dotted line will then disappear.

With this image I used the same brush but altered the colour to add extra highlights to the flesh areas beneath the eye and above the nose. I then reduced the size of the brush to a very small 6px, adjusted the flow to 100% and applied detailed strands of hair to the eyebrow.

CREATING A GRADUATED BACKGROUND

To create a sky-effect background for an artwork, first click on the magic wand icon highlighted second from the top on the right-hand side of the toolbox, then click anywhere in the area you require to be sky. A shimmering dotted line will encompass your image and the four sides of the drawing area. Note the tolerance setting (highlighted third from left at the top) that affects the accuracy of the selection; if you want a sharp image choose a high tolerance, but if you are working in a more sketchy fashion go for a lower setting.

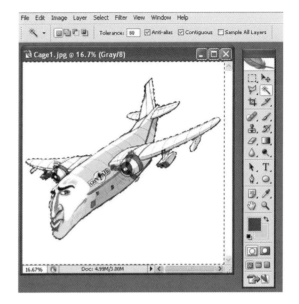

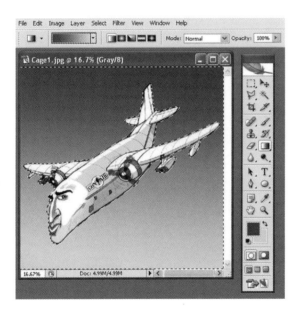

Choose the gradient icon highlighted sixth from the top on the right. Click and keep pressed at the top of the image then drag downwards. The area minus the image in the centre will then fill with a graduated tone. The icon fourth from the bottom, where one square overlaps the other, shows the two colours I chose to graduate together.

Finally, under the Select menu at the top of the screen, choose Deselect. The shimmering lines will disappear and you'll be left with an excellent sky effect.

MANIPULATING IMAGES

Sometimes you may look at a finished caricature and think that if only you had drawn a certain feature a little differently the end result would be much better. Fortunately, there are tools that allow you to transform what you have already drawn.

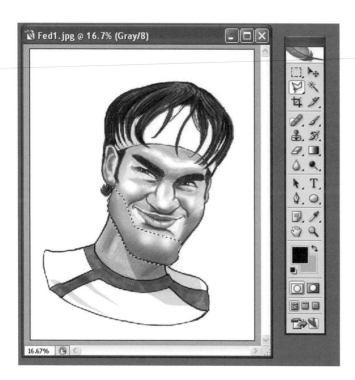

My favourite transform tool is the warp option, which allows you to make adjustments in size and shape to any part of your artwork. Use the polygonal lasso tool to encompass the area you wish to alter by clicking around it. Once it is fully encompassed a shimmering dotted line will appear as before.

Go to Edit in your top menu bar, then in the drop-down menu choose Transform then Warp.

A grid with dots on the corners of each of the squares will appear around the area you marked.

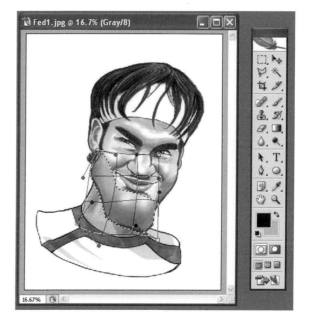

Using your cursor, choose a dot closest to the area you wish to manipulate and then drag it in the direction you wish to increase or decrease. Once you are happy with the look of your artwork, click on one of the icons from the right-hand toolbox to deactivate the grid and then save your image.

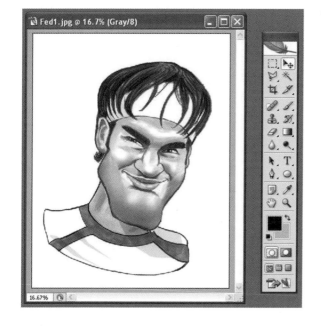

The chin is now far too big and the caricature looks less like Roger Federer than it did previously, but you can see the warp tool's potential. Try to use it only on a limited basis – your drawing skills will not advance if you become too reliant upon it.

THE SKY'S NO LIMIT

Sir Richard Branson, the English billionaire entrepreneur, is an incredibly dynamic and charismatic man with a passion for constant exploration, pushing boundaries to the limit. I decided his caricature must be involved in something extreme and exhilarating, which is why I chose to draw him seated astride the Virgin Galactic like a rodeo cowboy blasting into space. I think it worked!

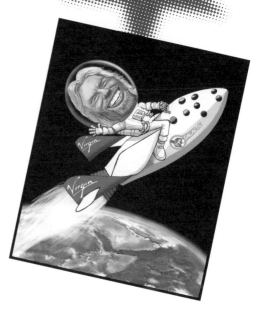

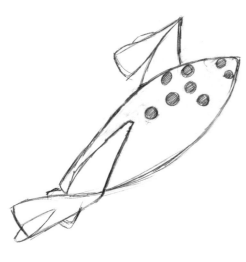

★ Whatever you decide to draw, it is worth sourcing photographs to use as reference. This was my first pencil sketch from some photos I found of the Virgin Galactic. It's very basic but the overall look is there.

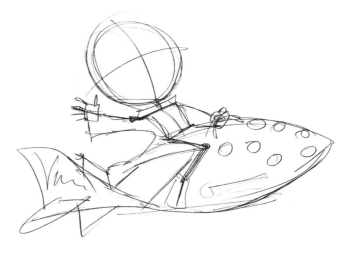

★ Next I added a rough matchstick figure on top to get a feel for composition and balance.

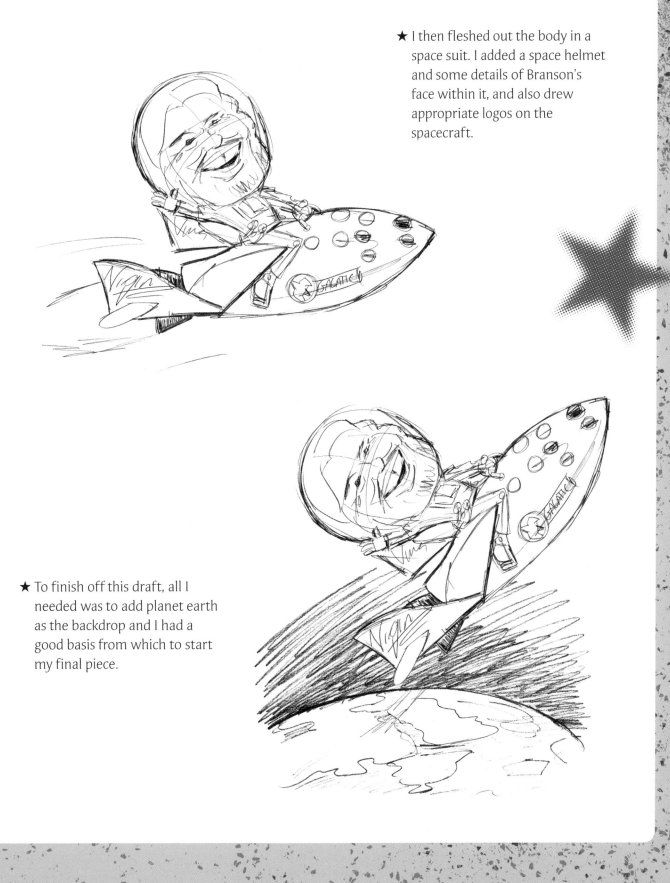

★ I then fleshed out the body in a space suit. I added a space helmet and some details of Branson's face within it, and also drew appropriate logos on the spacecraft.

★ To finish off this draft, all I needed was to add planet earth as the backdrop and I had a good basis from which to start my final piece.

★ The next step was to create a more detailed pencil caricature sketch of Branson himself. His wide, bright smile, well-groomed facial hair and windswept hairstyle were all key features to work on. His cheekbones are pronounced and his jawline is strong. Perhaps because he is often smiling, in most reference photos his eyes appear quite scrunched up, almost squinting. Although this caricature would eventually be positioned at an angle I find achieving a good resemblance easier with a subject placed upright on the page.

★ Once I was reasonably happy with my caricature sketch I placed it at the appropriate angle on a light box and traced it lightly on to a piece of Bristol board, adding a neatened version of his body and spacecraft beneath.

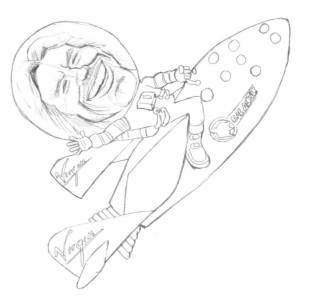

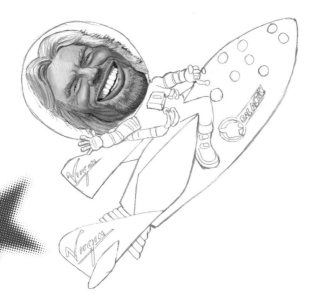

★ I like to render the face first, and to do this I used a combination of polychromos artists' pencils and some water-soluble artists' crayons for the skin tones. I finished off the hair and any dark edging with a black fineliner pen. I also added some highlights to the hair and beard using white gouache paint applied with a small fine paintbrush.

 The next stage was to go over the pencil lines of the body and spacecraft with a black fineliner pen. Once the ink had dried (about five minutes) I rubbed out all the pencil marks, leaving just the ink lines behind.

★ Now it was just a matter of working up the background and details of the spacecraft to create the look I wanted for my final piece.

5. The black sky could be applied by hand using either ink or paint. However, as I was going to scan this artwork, it was easier to add in with the fill tool in Photoshop.

4. The spacecraft was rendered using a variety of felt markers and later touched up using the airbrush tool in Photoshop.

3. The glass effect of the space helmet was also created using the airbrush tool in Photoshop.

2. The earth was initially drawn by hand with a combination of felt markers and crayons. The airbrush tool was used once again to blur the image and create a haze around the earth's surface.

1. Finally, I created the white-hot jet blast using the paintbrush tool in Photoshop. However, the same effect could have been achieved by hand, using white gouache.

'Blast off!'

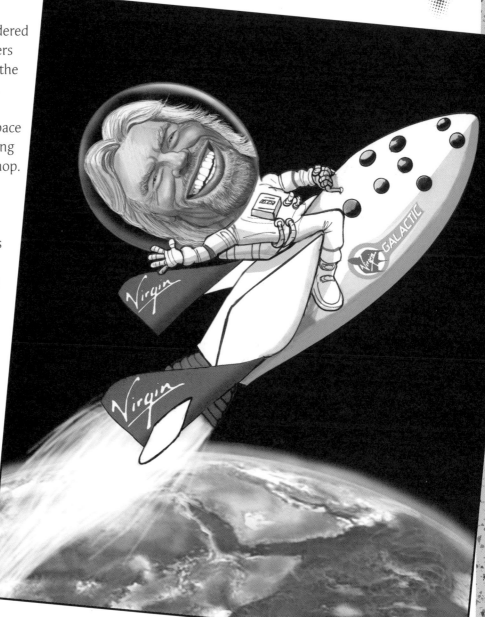

Index